STAYING POOR:

How the
Job Training Partnership Act
Fails Women

by

JO SANDERS

The Scarecrow Press, Inc.
Metuchen, N.J., & London
1988

OTHER BOOKS BY JO SANDERS:

The Nuts and Bolts of NTO: How to Help Women Enter NonTraditional
 Occupations
The Neuter Computer: Computers for Girls and Boys (with Antonia
 Stone)

British Library Cataloguing-in-Publication data available

Library of Congress Cataloging-in-Publication Data

Sanders, Jo, 1943-
 Staying poor : how the Job Training Partnership Act fails women /
by Jo Sanders.
 p. cm.
 Bibliography: p.
 ISBN 0-8108-2067-6
 1. Occupational training for women--United States. I. Title.
HD6059.6.U6S26 1988
331.4'2592'0973--dc19 88-23913

CONTENTS

Preface iii

Highlights v

One. Women's Centers and the Job Training Partnership Act 1

 Data Collection Methodology 3
 About Women's Centers 5
 About the Job Training Partnership Act 9

Two. Training and Employment Issues 23

 Pre-Employment vs. Skill Training Programs 23
 On-the-Job Training (OJT) 31
 Occupational Segregation and
 Nontraditional Occupations (NTO) 37
 Short-Term Training 47
 Low Wages 50

Three. Support Services and Job Benefits 59

 Child care 59
 Transportation 69
 Sickness and Health Insurance 71
 Stipends While in Training 75
 Saving Money on Support Services 76

Four. Administration Issues 83

 Recruiting Program Participants 83
 Reimbursement and Cash Flow 87
 Data Collection and Distribution 89
 Female vs. Male Leadership in JTPA 92

Five. Applying for JTPA Contracts for Women 97

 Getting and Staying Funded 97
 Why Women's Centers Choose Not to Have JTPA Funding 103

Six. Conclusions and Recommendations 109

 The Women JTPA Serves and the Women It Doesn't 109
 How JTPA Fails Women 115
 Recommendations 123

Appendix A. Tables and Survey Results 133

 Data from Five Service Delivery Areas 133
 JTPA Women Interviewed in This Study 136
 National Survey of Women's Centers 138

Appendix B. Information Sources 155

 Interviews Conducted 155
 Organizations Surveyed 160

Appendix C. Bibliography 167

 National Studies and Publications on
 JTPA and Women 167
 State Studies and Publications on
 JTPA and Women 170
 General JTPA Publications (Not Specifically
 on Women) 171
 Legislation, Regulations, Hearings, and Summaries 172

Appendix D. Women's Centers in the United States
 by Sylvia Kramer 175

 History of Women's Centers 175
 Women's Centers Today 179

PREFACE

Here is what is being said about the Job Training Partnership Act's services to women by the people who know: staff at women's centers that have JTPA contracts, JTPA staff members, and the women who receive JTPA training:

"Millions of dollars are being poured into JTPA to train women for jobs that can't support them."

"The quick fix we give women doesn't solve the problem. It is probably a valid criticism that our programs aren't long enough for women, but it is necessary for us to do what we do for certain performance standards."

"JTPA isn't a program designed for community-based organizations or for women, but we make it work."

"We used to meet someone where she was. Now she has to meet us where we are."

"If you are white, slim, and attractive, you have a definite advantage as a JTPA client. That advantage borders on the unethical."

"JTPA assumes everyone will make sacrifices in order to better themselves."

"The amount of time a woman spends in the system should depend on the woman, not the system."

"We can empower women financially. We have the tools of liberation."

The project that collected these provocative viewpoints and produced this book was conducted by Women's Action Alliance in New York City, on a grant from the Ford Foundation; Dr. Shelby Miller was the Program Officer. In accordance with the Foundation's practice, responsibility for the content was left completely to the author.

I wish to express my gratitude to the Alliance staff members who commented on the manuscript: Sylvia Kramer, Meg Hargreaves, and Dominique Treboux; to Karen Greene, Dave Bedford, and Fred Guay of the Employment and Training Administration, who patiently answered my questions about JTPA; and to Lynn Gangone, who shared with me the traveling, interviewing, and hard thinking that went into this book.

<div align="right">

Jo Sanders
Women's Action Alliance
July 1988

</div>

iii

HIGHLIGHTS

This book reports on a study Women's Action Alliance conducted from 1987 to 1988 to assess the effect of the Job Training Partnership Act, or JTPA, on women. JTPA, which replaced the Comprehensive Employment and Training Act (CETA) in the fall of 1983, is the national job-training program for low-income individuals who need help in entering the labor market. The assessment was sought through the experience of three groups: women's centers, women who have been JTPA clients, and JTPA administrators and counselors. A national survey was conducted and site visits were made to fifteen women's centers from Florida to Washington State, at which about a hundred women's center staff members, JTPA staff, and JTPA women were interviewed. Data on job outcomes was obtained from five JTPA offices on a total of 14,912 men and women.

Key Findings

Women's Centers

o The women's centers that were likeliest to have JTPA contracts were unaffiliated with schools or other organizations, in existence longer, had a larger budget (beyond the amount of their JTPA contracts) and staff, and served a somewhat needier clientele.

Training and Employment Issues

o Over half the women's centers' contracts were for pre-employment programs focusing on self esteem, confidence building, life planning, etc., rather than skill training, and many women were proceeding directly to jobs from these programs. Pre-employment programs do not appear to give women advantages in the labor market after JTPA compared to skill training programs.

o Occupational segregation is extreme, with over two-thirds of all women in our sample concentrated in only two areas: clerical and sales, and service. Due to the negative effects of performance standards and sex-role stereotyping, few women are in nontraditional training programs.

o Short-term training is the norm, with most programs well under six months.

o Since 1983, the national performance standard for wage at placement has risen less than 1 percent to $4.95 an hour, while the cost of living has risen nearly 20 percent.

o Women earned an average of $4.72 an hour, 52 cents an hour less than men; most men earned more than $5 an hour, while few women did so. Nearly everyone interviewed agreed that low wages are a critical

problem for many women in JTPA, most of whom are the sole supports of their families.

o A woman would have to earn $6.37 an hour to live at the poverty line and pay child care costs for one child. With two children, she would have to earn $9.59 an hour.

o Creaming, or the selection of the most advantaged clients, is widespread in JTPA.

Support Services and Job Benefits

o Although child care was nearly always provided, this support service was nonetheless most often mentioned as seriously deficient by women's center staff and JTPA women during training as well as in post-JTPA jobs. Transportation was also an obstacle for women, but not as much so as child care.

o The lack of health insurance emerged as a major concern during JTPA training and in post-JTPA jobs.

o Some women are refused acceptance into JTPA because of high child care and other support costs, usually unofficially but in some cases officially.

Administration Issues

o Many women's center JTPA programs are harmed by the poor recruiting done for them by centralized intake agencies.

o The partial-payment system (for participant enrollment, completion, placement, etc.) to service providers with performance-based contracts can reinforce the prevalence of short-term training and hinder the provision of support services to women.

o Data about what happens to participants during and after JTPA is commonly unavailable disaggregated by sex, rendering invisible women's lower wages and the extent to which they are occupationally segregated.

o Some women's centers have strong reservations about the desirability of JTPA in view of its restrictions.

Conclusions and Recommendations

o JTPA as currently implemented is not sufficiently effective in moving low-income women out of poverty and into regular employment.

o The two largest obstacles for women in JTPA are creaming -- the

system's preference for women who are easy and inexpensive to train and place, and the low wages of JTPA jobs which do not pay enough for many women to support families on.

o The central reality for women in JTPA is that because they are often solely responsible for supporting children, inadequate support services and low wages affect them more severely than other trainees.

o The five major recommendations are:

-- Prevent creaming by separating incentive awards from exceeding performance standards.

-- Improve provision of support services by tailoring performance standards to clients' employment barriers.

-- Strengthen the new followup standard so that it applies to long-term job retention.

-- Provide full child care and health insurance to women in JTPA training and into the employment period as needed.

-- All four levels of JTPA -- Employment and Training Administration, governors, Service Delivery Areas, and local service providers -- must exercise leadership in improving service to women.

- - ONE - -

WOMEN'S CENTERS AND THE JOB TRAINING PARTNERSHIP ACT

IN THIS CHAPTER

Data Collection Methodology
About Women's Centers
About the Job Training Partnership Act

This report assesses the effect of the Job Training Partnership Act (JTPA) on women, as seen through the experiences of three groups:

o Women's centers, some with and some
 without JTPA contracts to serve women

o Women who are or have been JTPA clients

o JTPA administrators and counselors

The Job Training Partnership Act is the American public job-training program for low-income people with barriers to entry into the labor market. The legislation passed in 1982 and the program began in the fall of 1983 as a replacement to the Comprehensive Employment and

Training Act (CETA), which had been widely (and some say unfairly) criticized for waste and inadequate performance. Women's centers began to emerge in the late sixties in response to the modern women's movement as alternative social service organizations for women. Because of the centers' commitment to serving all women and the fact that they are often used by women at life transition points, we felt that a study of JTPA as seen through the prism of women's centers would be a unique contribution to the growing body of literature on JTPA.

As of this writing in the middle of 1988, there have been a number of national and state studies carried out of JTPA, the federal employment program that began in the fall of 1983 for low-income individuals. The most recent is the excellent and comprehensive national review of JTPA by Sar Levitan and Frank Gallo, **A Second Chance: Training for Jobs,** which draws on studies by independent researchers and government agencies, questionnaire responses, and interviews (see Appendix C, Bibliography, on this source and others). The Levitan/Gallo book, however, has little information on Women in JTPA. A few JTPA studies have focused exclusively on women, notably those by MDC Inc., Grinker Walker and Associates, and the Displaced Homemaker Network, but none were published more recently than 1986.

The studies have clearly pointed out several problems in the way women were being served, notably low wages and occupational segregation. However, most of them have two serious drawbacks. First, with the

exception of the Displaced Homemakers Network report, studies have focused on Service Delivery Area (SDA) staff, the local administrators of the JTPA system, rather than the contractors who are providing training services directly to women and therefore presumably are better aware of their needs. Second, no study of women in JTPA interviewed the women themselves --, who, after all, know better than anyone what women in JTPA need. Our report draws heavily on interviews with these two groups as well as JTPA officials and staff.

Data Collection Methodology

We mailed questionnaires to 150 women's centers across the United States. Most were members of the National Association of Women's Centers; the remainder were drawn at random from lists of women's centers compiled by Women's Action Alliance. Eighty-eight responses were received, a response rate of 59 percent; 40 states and the District of Columbia were represented. Women's centers in states with low population density responded slightly less frequently than those in highly populated and relatively urban states, but otherwise the sample was representative. Part I of the survey asked questions about the structure and activities of the women's centers, while Part II asked questions about their JTPA experience.

Project staff then visited 15 of the 88 centers that had responded to the survey. Because of our interview approach, our primary selection criterion was our sense that the center had a great deal to teach us, either because it had an unusually large number of JTPA contracts and/or because the center director had written an unusually thoughtful opinion about women in JTPA in her questionnaire response. We also wanted to visit centers with a range of JTPA experience, from ongoing contracts to never applied. Beyond these criteria, we looked for a good mix in other factors:

o Geographic location

o Affiliation status (affiliated or independent)

o Annual budget

o Racial/ethnic groups of clientele

o Extent of program diversity

In this manner, we chose to vist 15 women's centers in Sacramento and Stockton, California; Colorado Springs and Golden, Colorado; Washington, D.C.; Tampa, Florida; Fort Wayne, Indiana; Louisville, Kentucky; Muskegon, Michigan; Buffalo, New York; East Stroudsburg, Pennsylvania; Houston, Texas; Everett, Washington; and Milwaukee and Waukesha, Wisconsin. Six of the centers had on-going JTPA contracts, four once had contracts but no longer did, and five never had contracts. We visited JTPA offices in ten sites. Over all 15 sites, we conducted 99 interviews as follows:

4

33 women's center staff members

31 women in JTPA

16 JTPA administrators and counselors

10 other community-based JTPA contractors for women

4 centralized JTPA intake centers

3 Private Industry Council (PIC) meetings attended

2 local women's groups/networks

We did not intend to carry out a large-scale quantitative study of women in JTPA, preferring instead a qualitative approach for this project. Despite the constraints of the limited scope and little quantitative data, we believe this report is valuable for its personal dimension. Women, women's center staff, JTPA administrators and counselors, and others described their experiences with the job training program in often moving detail. We hope their words and stories give you a degree of understanding that perhaps you might not have gained from another approach.

About Women's Centers

Women's centers are multi-service alternative social service organizations run by women for women. Sylvia Kramer, an expert on the history of the women's center movement, traces its beginnings to the 1960's in response to the modern women's movement: "Sometimes part of a

university or college but most often an independent storefront, a women's center provided a space and a focus for the re-emergent feminist activism of that time. In the late 60's and early 70's, women's centers offered conscious-raising sessions, rape speakouts, peer and professional feminist counseling, and other controversial events, including referrals to women gynecologists and the few reputable clinics that provided abortions in those days." (See Appendix D for Ms. Kramer's paper on the history and current status of women's centers in the United States.)

Today there are thousands of women's centers in the United States. Some are affiliated with schools of various sorts -- community colleges or technical institutes, colleges, and universities. Others are affiliated with large organizations such as the YWCA, and still others are independent neighborhood organizations. They range from virtually no budget at all to budgets well in excess of a million dollars a year. Some are single-focus organizations -- women's health, for example, or a battered women's shelter, while others provide dozens of informational, employment, and personal/family intervention services. Hundreds of thousands of women every year come to their local women's centers for help, often at major transition points in their lives. Centers tend to be local institutions women trust: compared with official social service agencies, women's centers are far likelier to be free of red tape, staffed by caring female personnel, and to offer assistance to women in a dignified, noncondescending environment.

6

A complete analysis of the 88 women's centers that responded to our survey can be found in Appendix A; the centers themselves are listed in Appendix B. Here we present a summary of the centers in our sample.

Profile of Women's Centers

JTPA status. Seventeen centers, or 19 percent of the sample of 88, reported having JTPA contracts currently or in the past.

Affiliation status. About two-thirds of the centers were affiliated with educational or service institutions of some kind, and about a third were independent. The independent centers, however, were much likelier to have JTPA contracts than affiliated centers.

Years in operation. The women's centers were quite stable, with an average age of more than 10 years. JTPA centers tended to be in existence longer than centers without JTPA contracts.

Size. Centers tended to have more than one location serving clients, especially JTPA centers. Centers on the average tended to have about 40 paid and volunteer staff members, while JTPA centers had about 80.

Budgets. The average budget of all centers was a quarter of a million dollars annually, but that of JTPA centers was more than half a million dollars. The value of the JTPA contracts accounted for only half the

difference. The lowest annual budget was $1,000; the highest, $1,300,000. JTPA centers raised funds from more sources than non-JTPA centers.

Networking. Most women's centers network in their community with other groups working on issues of common concern, with JTPA centers slightly more likely to network extensively than the others.

Clientele. Centers reported serving an average of over four thousand clients each last year, most of whom were women. JTPA centers served more clients than non-JTPA centers. The racial/ethnic mix of the women they served roughly corresponds to the racial/ethnic mix in the American population. The age of the clients falls in a bell-curve pattern, with just under half in their twenties and thirties; JTPA centers, however, tended to serve women in their forties and fifties. Centers reported serving poor, low-income, and middle-income women roughly equally, although JTPA centers tended more toward the low end of the income spectrum than the others. Women served by centers were likely to be single parents, especially at JTPA centers.

Services. The top five services offered by women's centers are information and referral, personal counseling, employment services, career counseling, and domestic violence assistance, with JTPA centers emphasizing employment and domestic violence more than the others. The major issues addressed in support groups and individual counseling are:

violence (battering, rape, abuse), employment, couple problems, and parenting issues. Centers with JTPA contracts were more likely to run battered women's shelters, rape or other crisis hotlines, and displaced homemakers programs than centers without JTPA contracts.

From this quick sketch, one can clearly see the multi-service nature of women's centers, and the fact that centers with JTPA contracts tend to be larger, older, have bigger budgets, and offer a wider variety of services. They also tend to serve a somewhat needier population than centers without contracts. It would seem that centers need to reach a critical mass in size, funding base, and service mix before they can take on as major an undertaking as a JTPA contract.

About the Job Training Partnership Act

The Job Training Partnership Act was passed in 1982 as a replacement for the Comprehensive Employment and Training Act, or CETA. The first major lesson we learned had to do with this fact. In describing the project to our friends and acquaintances -- people without professional connection to JTPA but nevertheless educated and well-informed people, they reacted blankly to our mention of JTPA. "The Job Training Partnership Act," we elaborated. Still blank. "Did you know what CETA was?" The response to this question was invariably "Of course." We suggest you try it, too.

JTPA, in other words, seems hardly known to the general public outside the job-training community. We do not know whether low-income people, JTPA's target population, are also less likely to have heard of JTPA than of CETA. Since JTPA is widely estimated to have only enough money to serve less than five percent of the eligible population, however, perhaps the program's low profile is deliberate.

What follows is not a complete description of JTPA, which is available in the Levitan/Gallo book mentioned earlier and elsewhere, but merely enough of the highlights that a reader unfamiliar with the program will be able to understand the rest of the book.

Administrative Structure

The purpose of JTPA, which went into operation in the fall of 1983, is "to establish programs to prepare youth and unskilled adults for entry into the labor force and to afford job training to those economically disadvantaged individuals facing serious barriers to employment." (Section 2 of the legislation). To carry out these programs, the following administrative structure was created:

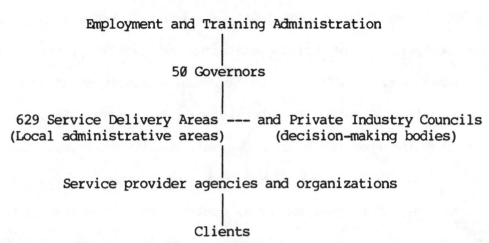

U.S. Department of Labor

Employment and Training Administration

50 Governors

629 Service Delivery Areas --- and Private Industry Councils
(Local administrative areas) (decision-making bodies)

Service provider agencies and organizations

Clients

The Service Delivery Area (SDA) is the basic local JTPA unit: a geographic region that encompasses a labor market area. As of this writing, there are 629 of them in the United States. For our purposes, the two major components of an SDA are the Private Industry Council and the administrative agency.

The Private Industry Council, or the PIC, must by law be composed of a majority of private-sector representatives, mostly employers; such a person must chair the PIC as well. The remainder of the PIC members are representatives from education plus non-specified others. These others are often from community-based or other nonprofit organizations. The major functions of the PIC are to set policy, provide program oversight, and approve contracts and official plans and documents.

The administrative agency for JTPA is commonly referred to as the SDA, even though this is technically incorrect. Chosen jointly by the PIC and local elected officials and approved by the governor of the state, the SDA is usually a city or county department of employment; less frequently one finds JTPA administered by consortiums, planning commissions, incorporated PICs, and even community colleges. The major function of the SDA is to administer the JTPA program -- issue requests for proposals, select and supervise contractors, collect data, prepare reports, and so forth -- in accordance with PIC decisions. SDA staffs in some places perform program functions as well: recruitment and intake, verification of client eligibility, assessment and assignment to JTPA activities, and occasionally others.

In our limited observation, the balance of power between SDAs and PICs varies according to the history of a similar structure previously under CETA, and also according to the personalities and political abilities of the people involved.

Performance Standards

The framework of the program in practice is a series of performance standards, requirements that must be met by JTPA administrative and service-provision agencies up and down the line, that stress hard results. The law says:

The Congress recognizes that job training is an
investment in human capital and not an expense. In order
to determine whether that investment has been productive,
the Congress finds that ... the basic return on the
investment is to be measured by the increased employment
and earnings of participants and the reductions in
welfare dependency. [Section 106(a) and (2)]

We will be returning to this language later. Out of it were developed

the four performance standards that have governed the program's service

to adults since its beginning. "Adult," as defined by the law, means 22

years of age and up.

1. **Adult Entered Employment Rate,** or placement rate. This is the

 percentage of adult JTPA clients who are placed within 90 days after

 their last job training or other JTPA activity. There is no federal

 minimum number of hours per week needed for a job to classify as a

 placement, although many states set minimums.

2. **Welfare Entered Employment Rate.** This is the same as the preceding,

 but for welfare recipients. This performance standard is therefore

 a subset of the one above. The welfare placement rate is lower than

 the adult version in recognition of the more extensive barriers to

 employment that welfare recipients typically have.

3. **Adult Average Wage at Placement.** This means hourly wage.

4. **Adult Cost per Placement.** For most JTPA contracts, this means all

reported expenditures -- administrative costs, support services, and training -- divided by the number of placements.

The Employment and Training Administration in the U.S. Department of Labor is responsible for setting the national performance standards, which by law cannot be changed more often than every two years. ETA bases them on prior experience, generally at the level which predicts that three-fourths or more of the SDAs will be able to meet them. State governors then adjust these guidelines up and down slightly for each SDA to take into account factors such as the local unemployment level, the presence in the local population of unusually large numbers of people with unusually severe employment handicaps, and the like. Governors are free to make further performance-standard adjustments for individual SDAs with special needs or target groups.

Finally, local SDAs are responsible for meeting performance standards set for them at the state level. They usually do this by issuing "performance-based contracts" which specify performance standards for individual contractors. SDAs are free to issue contracts with widely varying performance standards according to the needs of local populations and training activities, so long as the cumulative record meets the standards for the SDA as a whole.

The national performance standards for each Program Year (which

begins on October 1 of the preceding year) since the beginning of the program in the fall of 1983 are as follows:

National Performance Standards for Adults, 1983-1989

Performance standard	Program Year	Value	Percent change, '83-'89
Adult entered employment rate	1984-1985	55%	
	1986-1987	62%	
	1988-1989	68%	24% increase
Welfare entered employment rate	1984-1985	39%	
	1986-1987	51%	
	1988-1989	56%	44% increase
Adult average wage at placement	1984-1985	$4.91	
	1986-1987	$4.91	
	1988-1989	$4.95	0.8% increase
Adult cost per placement	1984-1985	$5,704	
	1986-1987	$4,374	
	1988-1989	$4,500	21% decrease

JTPA administrators have been required to place more people with less money over the five years or so since the beginning of the program. We are particularly concerned about the wage at placement figure, which has risen less than one percent. To put this into proper perspective, the Bureau of Labor Statistics says that inflation has raised the cost of living nearly 20 percent since the fall of 1983 when JTPA began. In other words, JTPA clients getting placed in jobs today are about 19 percent poorer in constant dollars than they were in the fall of 1983.

15

Making the performance standards even more powerful a motive force in the system than they already are, six percent of a state's JTPA allocation is reserved for distribution to SDAs as incentive grants for exceeding performance standards. In fact, the amount of the award is proportional to the extent to which the standards are exceeded. The law specifically allows awarding incentive funds for serving "hard-to-serve individuals," but none of the SDAs we visited did so in 1987-88.

Incentive awards can be quite sizable; one of our SDAs received over $800,000 in extra funds this way, which amounted to a quarter of its total budget. SDAs can choose to use the money for new training contracts or they can use it to reward to contractors who earned it. They can also choose to keep part of it for salary bonuses. In practice, therefore, an SDA is quite inclined to do everything it can to get the placement rate up and the cost per placement down. Theoretically, SDAs should be just as motivated to get the wage at placement up, but in reality this performance standard is often seen as not very influenceable.

An obvious shortcoming of these performance standards is that all of them apply to the status of JTPA clients as of the day of job placement or three months after program completion, whichever occurs first. A person who becomes employed within the 90 days is thus recorded as a success, even if she or he quits the next day or is fired the next month. To correct the shortcoming somewhat, four new post-

program rates for adults are going into effect as of this year, 1987-88. Each new performance standard is to be measured 13 weeks after clients leave the JTPA system entirely. The standards and their national values are:

Adult followup employment rate	60 percent
Welfare followup employment rate	50 percent
Weeks worked during followup period	8
Weekly earnings of all employed at followup	$177

In other words, a dropout rate of up to eight percent is expected for adults (68 percent adult placement rate minus 60 percent adult followup rate), with up to a six percent drop for welfare recipients. Everyone will agree that measuring followup at only three months after placement or leaving the system is not very much followup, but it is an improvement. Incentive awards will also change somewhat, with governors now free to choose eight out of the total of twelve adult and youth standards as the basis for awards. States in which governors choose the followup employment rate and ignore the placement rate as an incentive award component can be expected to have very different JTPA programs from what the system has seen up to now.

Women in the JTPA Legislation

According to the Employment and Training Administration, 53 percent of those served by JTPA are women. Women are not mentioned in the JTPA legislation as a specific target group, on the theory that the definition of target populations was best left to the Private Industry Councils to permit greater responsiveness to local conditions. The closest the law comes to mentioning women are these instances:

o Up to 10 percent of JTPA clients can be people whose income exceeds the strict eligiblity limits but who have other serious labor market handicaps. "Such individuals may include, but are not limited to, those who have limited English-language proficiency, or are **displaced homemakers**, school dropouts, **teenage parents**, handicapped, older workers, veterans, offenders, alcoholics, addicts, or homeless." [Section 203 (a) (2); emphasis added] Displaced homemakers and teenage parents could be male, of course, but in usual practice are not considered so.

o "Recipients of payments made under the program of aid to families with dependent children ... shall be served on an equitable basis, taking into account their proportion of economically disadvantaged persons sixteen years of age or older in the area." [Section 203 (b) (3)]. Again in usual practice, most AFDC recipients are women. We have seen that welfare recipients have their own version of the

18

placement and followup performance standards.

o There is also a mention of single heads of households with dependent
 children, to be cited soon.

Support services are permitted under the act, as are needs-based
payments. According the the legislation, funds may be used for:

> Supportive services necessary to enable individuals to
> participate in the program and to assist them in
> retaining employment for a period not to exceed six
> months following completion of training. [Section 204
> (11)]

Support services, in other words, can be almost anything an SDA says
they are, as long as people need them to stay in training and get and
keep jobs. The cost of support services, however, cannot exceed 15
percent of an SDA's total allocation. This is not much to spend on
support services. SDAs may apply for a waiver of the 15 percent cap on
support services if one or more of the following circumstances apply:

o Local unemployment is especially high,

o Training programs are nine months or longer,

o Child care or transportation costs are especially high, and/or

o The SDA "proposes to serve a disproportionately high number from groups requiring exceptional supportive service costs, such as ... single parents with dependent children." [Section 108 (c) (2) (B)]

Published studies on JTPA agree that few SDAs have applied for waivers, and none of those we visited had done so. This is understandable, however: a waiver is merely permission to reallocate some money from training to support services. It does not increase the total SDA allocation. Since SDAs see themselves in the job training business and not the child care business, the voluntary reduction of their training funds is naturally not an attractive proposition. It is no wonder they are reluctant to apply for waivers.

Finally, nontraditional occupations are mentioned in the legislation, although not specifically for women and more in the way of a helpful suggestion than a requirement. We will discuss this further in the next chapter.

JTPA Activities

People certified as eligible to receive JTPA services have, at least in theory, a number of choices as to program activities. The ones we found were most common were these:

o **Classroom training.** This traditional teaching approach is one major way job skills are taught.

o **On-the-job training, or OJT.** This is the other major way. A client is placed with an employer, who receives a subsidy of half the client's wages for up to six months in exchange for training provided to the client. The understanding is that the client will continue on thereafter as a regular, unsubsidized employee.

o **Job Search.** Clients who have job skills are helped with resume preparation and job search techniques.

o **Basic skills,** or remedial academic education, for people who will be going into skills training but need to improve their reading and/or math skills first. Some SDAs include the GED (high school equivalency diploma) here.

o **Pre-employment.** This is a term we have learned means different things to different people. It is probably classified differently from SDA to SDA: as classroom training (for confidence-building and self-analysis services for people not yet ready to choose a job direction), Job Search, or separately as pre-employment. Even more confusing, people who complete these programs can go next (or even simultaneously) to any of the preceding activities or else directly to jobs.

With these short courses in women's centers and JTPA out of the way, we will proceed with what we learned in the course of our inquiry.

- - TWO - -

TRAINING AND EMPLOYMENT ISSUES

IN THIS CHAPTER

Pre-Employment vs. Skill Training Programs
On-the-Job Training (OJT)
Occupational Segregation and Nontraditional Occupations (NTO)
Short-Term Training
Low Wages

Pre-Employment vs. Skill Training Programs

Most of the women's centers we surveyed -- 81 percent -- never had a JTPA contract of any kind. Of the remaining centers, slightly more than half their contracts were for pre-employment programs for women (as opposed to skill training or, in a couple of cases, service contracts to the SDA). Typically, a pre-employment program focused on the needs of women who had been out of the job market for a long time, such as women on welfare, displaced homemakers, or women with other special labor market barriers. We visited seven women's centers that were running or had run this type of program, and were particularly interested in the

23

extent to which women were helped by pre-employment programs ultimately to obtain jobs they and their families could live on.

Pre-employment programs usually met in cycles of a few weeks, several hours a day, and tended to include many of the following: self esteem, stress management, goal setting, time management, assertiveness training, values and skills assessment, life planning, career decision-making, job search techniques and support groups, interviewing and resume preparation, academic brush-up, and counseling on career, personal, and academic issues. Clearly, the agenda of the pre-employment program is multifaceted, woman-centered, and responds to the often urgent needs of women who have been out of the job market for support and assistance through this major life transition. Centers with pre-employment contracts felt that JTPA staff were not able to provide the services directly, either through a lack of time or a lack of sensitivity.

Without exception, the women we spoke with who attended pre-employment programs at women's centers were positive about the experience. As one woman said,

> The best thing they [JTPA] did for me was telling me I had to come here. It changed my attitudes, my self-esteem. Without the center, I'd probably still be on AFDC, still trying to figure out what I wanted to do.

Many of the women kept in touch with the women's center staff after the end of the program, as indeed they were invited to do. The women repeatedly mentioned the supportive environment and encouragement they received as critically important to them. We saw a clear need for this kind of help ourselves. For example, we usually began interviews with women in JTPA by asking them to tell us what they were doing before coming to JTPA. The usual -- and usually highly inaccurate -- answer was, "Nothing." We mentioned this to a man who was an administrator in a vocational school we visited. He understood immediately, and told us this story:

> There was a woman at the employment office a couple of years ago. She and her husband were farmers, and he died. She kept the farm. She came through the employment office to get a job because she didn't feel she was going to make it on the farm. She told an employment counselor, "I need a job, but I don't have any skills." I just happened to be there and sat down. I asked her a lot of questions and found out that her farm was about 100 acres, she gets up at 4 o'clock every day to do the chores and goes to bed when the sun goes down. When equipment broke, "I generally fixed it myself -- I welded this, I wired that." She knew how to rotate the crops by working at the computer. She had four people working for her. We went through this whole thing, and this lady was saying she had no skills.

The strength of women's centers is their commitment to supporting women in need of help, and it is a critically important strength. Unfortunately, it may be simultaneously a weakness. Pre-employment program staff, when asked what constituted success, answered "increased confidence on the part of women" or variations on that theme. This is

obviously important, but only as a means to an end. These staff members paid less attention to what in our view is finally the ultimate point of JTPA participation: jobs and wages. The career exploration they offered to women tended to be haphazard, a minor focus of the program. A few programs devoted a session to a tour of the local vocational school or community college and called that career exploration. The pre-employment programs typically did not go into detail about wages and working conditions of various careers.

The pre-employment staff usually did not know what happened to women who left their programs: the SDA did not distribute data (indeed, some did not even have it to distribute), and limited staff time made followup difficult. One staff member "guesstimated" that based on post-program informal contacts, a third of the program completers went on for skill training, a third found jobs directly, and a third somehow disappeared. What surprised us was not that staff did not know what happened to the women who had been through their programs, but that few tried actively or systematically to find out even within the constraints of followup difficulties. For example, the staff of the only women's center we visited that received regular SDA status reports on the placement and wages of its participants simply filed the reports without examining them. Pre-employment program staff therefore did not have the information they needed to assess the effectiveness of their own programs.

There is mixed evidence of the effectiveness of pre-employment programs from SDA data. There were only three SDAs that gave us figures comparing wage at placement for women's center pre-employment graduates vs. figures for women in the entire SDA and men in the SDA. The pre-employment women earned more than SDA women in general in two of the SDAs, while they earned less in the third. In all cases, however, the pre-employment women -- like the other women -- earned less than men.

Comparison of Average Wage at Placement: Women's Center Women vs. Women and Men in SDAs

Service Delivery Areas	Average Wage at Placement		
	Women's Ctr. women	All Women in SDA	All Men in SDA
SDA 1	$4.78	$4.99	$6.13
SDA 2	$4.75	$4.59	$4.95
SDA 3	$5.00	$4.62	$5.14

Comparable SDA data on women's centers that ran skill training programs was not available, but in fact this data would not be sufficient to determine the effectiveness of pre-employment programs for women. One really would need to compare the job market performance of women who took a pre-employment and then a skill training program with that of a comparable group who participated in skill training alone. The SDAs we visited did not have such data.

Another way to assess the value of pre-employment programs is to compare the outcome of participation among the 31 women we interviewed, about a third of whom had taken or were in the process of taking such a program. About half of this group were still in training, a quarter were job hunting or had given up finding a job, and a quarter were working. These were the same proportions for the other two-thirds who had not taken pre-employment programs.

Next we looked at the jobs these women had. Of the three pre-employment women who were working, one had an involuntarily part-time clerical job in a nursing home, another had a job with a housecleaning service, and the third had an electronic assembly job. Of the three, only the latter had participated in a skill training program after her pre-employment program, and at $5.94 per hour had the highest wage. However, five more pre-employment women were in skill training at the time of our interviews with them and may end up with higher-paying jobs.

By contrast, the five working women who did not participate in a pre-employment program were earning substantially more money. Like the others, they had been out of JTPA for approximately a year. Three had completed clerical training (via a classroom program, an OJT assignment, and a work experience assignment in the JTPA office), and they were now making from $6 to $7.15 an hour. The fourth had taken a classroom program as a medical receptionist and was working voluntarily part-time (she wanted to spend more time with her small son) at $6.70 an hour.

The fifth woman had gone through JTPA twice (took the production machine program, worked, got laid off, and returned to take the advanced machine program) and was working as a machinist for $8 an hour.

While we cannot draw any solid conclusions from this limited evidence, it is a matter of some concern that the pre-employment programs, a type of programming often considered a special strength of women's centers, did not appear to lead to clear advantages or even an equal position in the job market later for the women who took them. This is not to question the value of pre-employment services **per se**, which are clearly needed to assist women who have little work experience and are far from job-ready. We are rather questioning the effectiveness of stand-alone pre-employment training. We do not know if some women are proceeding directly to the job market because they cannot afford to participate in the stipendless JTPA program any longer, because local JTPA regulations prohibit a participant from enrolling in two sequential programs, or other reasons. Doubtless the reasons vary from SDA to SDA.

Of the ten women's centers that had JTPA contracts currently or previously, only three offered some type of skill training. They had four skill training contracts among them. Two were OJT contracts that placed women into various occupations with various employers at various locations around town. The third contract was for a classroom program for older (55+)workers, mostly women, as home health aides and in office skills; the classrooms were located at the center's large old building.

The fourth contract was for a classroom program in which women were trained as electronics technicians, with the training facilities located at the women's center. The center that ran this contract had so many difficulties with JTPA that it has chosen to operate its job training programs with funds from sources other than JTPA. Based on our interviews with women, it would seem that skill training and not only pre-employment is the route to follow if women are to become economically self-sufficient. Why did so many centers bypass skill training in favor of pre-employment programs?

One reason for the tilt towards pre-employment programs is that many women's centers are established to provide woman-focused support services. Centers typically do not duplicate services available elsewhere. As a result, many women's centers have not seen job training, which exists elsewhere, as part of their mission. On the other hand, some women's centers that had offered extensive skill training programs with CETA funds were forced to retrench with the funding cutbacks when JTPA replaced CETA in 1983. Some of them maintained an employment function with JTPA-funded pre-employment programs, while others left the employment field entirely.

Another reason for the prevalence of pre-employment programs is the lack of job training facilities at most women's centers, a significant factor since most of the centers that had any kind of JTPA contract were independent unaffiliated centers. The typical neighborhood women's

center, after all, cannot afford to set up a fully equipped electronics or drafting classroom, but all it needs for a pre-employment program is a room, some tables and chairs, and a blackboard. It is perhaps the facilities factor that decided two of the four centers that had skill training contracts in favor of OJT, for which only an office is needed.

It seemed to us that a shared contract -- a women's center with a community college, let us say -- would be a strong combination that would simultaneously fulfill women's need for woman-focused support and their need for saleable job skills. Each organization would contribute what it was best suited to do. (The only school-affiliated women's center we visited that had a JTPA contract, and therefore presumably had easy access to training facilities, had a pre-employment contract with 8 percent setaside funds for educational programs; the goal of the contract was to support women's entry into the college.) When we asked SDA staff members whether they had ever considered such a joint center/school arrangement, they said no. Only one women's center told us they had thought about this, but the proposal they developed with a local community college was turned down by JTPA as too expensive.

On-the-Job Training -- OJT

On-the-job training, or OJT, is a type of skills training in which relatively skilled JTPA participants are assigned to individual

employers rather than classroom situations. Employers receive a subsidy of 50 percent of the trainees' wage for up to six months in compensation for the training provided to the trainees. OJT is a favored training vehicle in JTPA because wages tend to be slightly higher than average and placement is somewhat better (since many trainees become employees).

Women were underrepresented in OJT, in proportion to their presence in JTPA, in all the SDAs that gave us data: they were usually about a third of the OJT trainees although they were slightly more than half of all trainees. Two of the centers we visited had OJT contracts to place women in a variety of occupations. We also heard something about OJT from several of the women we interviewed. Among them, three issues were raised: recruiting employers, program abuses, and the relationship of OJT to nontraditional occupations (NTO) for women.

Both OJT centers spoke of how hard it was to get employers to sign up for the program. "Employers see OJTs as cumbersome, and the larger businesses are just not interested in it," said one center director, explaining that employers in her area strongly disliked the paperwork requirements and had an aversion to getting mixed up with government programs. The other center director pointed out that although relatively skilled participants are assigned to OJT, they often are rather unskilled compared to the employers' work force. She found it hard to convince employers to take on JTPA workers. In both centers, the consequence is that an OJT contract was difficult to undertake

32

because staff had to work at least as hard to recruit employers as they did to recruit women for the OJT slots.

Second, we were told about abuses of the OJT program. There was plenty of creaming reported, or selecting those with built-in advantages who are likely to need little help from JTPA to succeed. Employers frequently preferred OJT trainees with excellent job skills who needed little or no training. At a 50 percent wage subsidy for up to half a year, such employees are a real bargain.

The most egregious case of OJT creaming we heard in our visits was a 36-year-old white woman with a college degree, single with no children, whose OJT placement was working for an animal welfare rights organization as an assistant art director to produce a magazine. This person had had a bewildering variety of jobs (including research assistant at a state Manpower agency, darkroom photographer, assistant law librarian, and many others), periods of unemployment, and college enrollment stints, because she hadn't wanted full-time permanent jobs. She was earning $8.45 an hour in her OJT placement, half of which was paid in subsidy to the employer out of the women's center's contract. We naturally asked about the training she was receiving from her supervisor. "I don't really need training on this job," she said. "I've done all these things before."

This woman happened to be highly skilled, but another women in an OJT file clerk placement at $5 an hour also described receiving no training: "The filing is very simple. They don't really have to teach me how to do it." It was apparently so simple that she was concerned about having no more saleable skills than when she started.

Beyond employers receiving free subsidies, as it were, we several times about OJT employees getting fired or laid off at the end of their subsidy period. In one case, a woman told us she was very much afraid of being laid off from her OJT job as her friend was at the end of hers, especially since she was no longer receiving welfare checks because of her OJT job. Elsewhere, a PIC member told us that his SDA had a problem with employers who fired JTPA workers when their subsidy ended.

Still another subsidy-abuse story was quite strange. A woman began an OJT placement as a receptionist at $5 an hour, to be subsidized for eight weeks. Toward the end of that time, her employer told her that she was mixing up orders because of her "hearing problem". The woman discovered that her predecessor, another OJT woman, had also been fired at the end of her subsidy period for having an alleged hearing problem. She called her JTPA intake center field representative to report that she was about to be fired for a false reason, but the field rep did nothing. She was fired shortly afterward; a doctor checked her hearing and found nothing wrong. The woman was convinced she was fired because her employer didn't want to pay full salary or benefits after the

subsidy period. She was still unemployed when we met her two months later.

Finally, a woman told us about being hired as an OJT receptionist at $4 an hour, for a company that assembled electronic components. She worked as a receptionist for one day before being reassigned to the factory to do assembly work that normally paid a higher wage. The woman said,

> That was just their way of getting cheap help, I think. As soon as the contract was up, I got laid off -- they thought they was going to get more help at half price.

This woman had a women's center behind her, but -- this is an excellent example of the power of performance standards -- the center had not been doing well in placements lately and did not dare jeopardize this one. All the center could do, the center director told us, was call the employer and ask him to reassign the woman back as a receptionist. The call was made, but the woman remained an assembler until she was laid off at the end of the subsidy period.

Had we heard only one of these abuse stories, or even two, we would have been tempted to write it off. More than two, however, indicates the existence of a problem that may be widespread. It may not, of course, be a problem that is particular to women only.

The third and most surprising OJT discovery we made, however, is how OJT works against nontraditional occupational (NTO) placements. This situation relates to the fact that in an OJT budget proposal, the contractor can only estimate the average wage of the placements: not knowing the clients in advance, the wages can't be known either. A women's center staff member told us about a woman she placed recently in a $12 an hour nontraditional OJT slot who had cost the program far more money than they had budgeted:

> Staff member: Nontraditional placements for women cost more [than traditional placements]. It's not cost-effective for a variable OJT program that operates on a fixed unit cost per client. It eats up our overhead costs. With her contract, we ended up $3,000 in the hole because we had to pay for her child care, pay for her work boots, pay for her union initiation, and half of her high wage. So if we did only nontraditional placements we wouldn't have a place to work from -- we'd go broke.
>
> Interviewer: Could you submit a proposal to JTPA for the real cost of NTO placements?
>
> Staff member: Of course not. We wouldn't get funded because the unit cost would be so high that it would hurt the SDA's numbers.

She added that when she had too many high-wage placements of this sort and a woman came in who wanted an NTO job and had some skills in the area, the woman was given suggestions on the side rather than told to complete the certification process and then return for NTO placement. A variable OJT program such as hers, she said, has to be sure to have enough low-wage placements in traditionally female jobs to balance out the nontraditional high-wage placements. In other words, the

36

traditional placements subsidize the nontraditional ones.

Occupational Segregation and Nontraditional Occupations (NTO)

Virtually all the people we spoke with in this project -- women's center staff, JTPA officials, JTPA-contracted vocational schools, women in JTPA programs, and others -- agreed that JTPA is a very sex-segregated job training system. This may begin in the relatively loose language found in the only reference to the reduction of occupational segregation to be found in the JTPA legislation: **"Efforts shall be made to develop programs which contribute to** occupational development, upward mobility, development of new careers, and **overcoming sex-stereotyping in occupations traditional for the other sex."** [Sec. 141(d)(2); emphasis added.] In other words, there is no requirement that states, SDAs, or training providers actually achieve significant nontraditional program enrollments. The path of least resistance is therefore that the JTPA system reinforces the occupational segregation occurring in the society at large.

Analysis of the data provided to us confirms the occupational segregation of JTPA. Of the ten women's centers that had JTPA experience, the only one providing explicitly nontraditional job training to women no longer had a JTPA contract. One other center had an OJT contract for variable occupational placements, discussed in the

37

last section; the center director emphasized NTO as a personal, not contractual, commitment. And as we saw, she did not make many NTO placements from her OJT contract.

Similarly, of the 31 women we interviewed, only three were (or had been) in a nontraditional program: machine shop. A full two-thirds of the women were in clerical programs or jobs, which is somewhat more than their presence in the JTPA population. This is the picture that emerges from data provided to us by five SDAs on occupational distributions for a combined total of 14,912 men and women. Sixty-nine percent of the women were employed after JTPA in only two of the nine commonly accepted areas: clerical and sales (43 percent), and service (26 percent). In contrast, men were relatively evenly distributed among the nine occupational areas, with 21 percent of men in the machine trades being the heaviest concentration. (See charts, next page.)

As one JTPA counselor told us in describing the training in her SDA,

> Men here go into classroom training in electronics, mechanics, drafting, and accounting. Women go into clerical training, mostly.

In another SDA, the president of a business college with many JTPA-funded students told us that most of his students were female because the local JTPA-funded vocational school offered "mostly male training programs." He was correct. While two machine shop programs at the school had a substantial proportion of women (30 percent and 24 percent)

OCCUPATIONAL DISTRIBUTION

MEN

			WOMEN
8.0%	1 ■	PROF. TECH, & MANAGERIAL	10.0%
11.0%	2 ▦	CLERICAL AND SALES	43.0%
19.0%	3 ▦	SERVICE	26.0%
3.0%	4 ▩	AGRI., FORESTRY, FISHING	1.0%
5.0%	5 ▦	PROCESSING (INDUSTRY)	2.0%
21.0%	6 ⊞	MACHINE TRADES	5.0%
8.0%	7 ▬	BENCHWORK (ASSEMBLY)	8.0%
14.0%	8 ▤	CONSTRUCTION	2.0%
11.0%	9 ▦	MISCELLANEOUS OCCUPATIONS	3.0%

39

due, we were told, to the snowball effect from a program that had existed a few years previously to encourage nontraditional occupations (NTO) for women, the welding program had 9 percent women; auto body, 8 percent; and auto mechanics, 0 percent. The "automated office worker" (sic) program was 94 percent female. The NTO program, by the way, was cancelled when a new women's center director convinced the SDA director that many more women would be served if the NTO focus were dropped from the center's contract. It was.

Another heavily male vocational school we visited underlined the extent to which women occasionally had to overcome considerable active or passive opposition from the system to enroll in a nontraditional program. In this school, prospective trainees were required to spend two weeks rotating among the various programs the school offered before choosing one. The difficulty in this arrangement for women can be seen in the following "Catch-22" exchange:

Director: The rotation is to make sure they understand what they're getting into, that it's a good fit. They have to be here every day, on time.
Interviewer: Is this before they're enrolled?
Director: They might be certified as eligible, but they're not enrolled yet.
Interviewer: So anyone who needs child care paid for can't get it then?
Director: True. JTPA makes that decision.
Interviewer: If a woman was sure she wanted the industrial maintenance program, could she enroll to get her child care paid for, skip the assessment period, and go right into the program?
Director: The assessment period is a requirement of our corporation.

People pointed many fingers at the causes of this occupational segregation. Some mentioned that women themselves choose traditionally female training programs:

> SDA staff member: In the tree trimming class we made a real attempt to get women into this program, but they wanted clerical.
>
> Women's center staff member: Women don't know the broad picture. They only know the stereotypes. They see their friends in clerical jobs and dressing up nice for work.
>
> SDA staff member: The counselors find that the women are still self-selecting the more traditional fields.
>
> Women's center staff member: We're battling both the corporate attitude, which is sexist, and the internalized sexism of women that we see.

People also mentioned JTPA counselors, vocational teachers, the women's center staff, and the community at large as being responsible for the overwhelming preponderance of women in female-intensive training programs. They may all be correct. What was apparent to us, however, is that there was virtually no career exploration occurring for JTPA-eligible women that would challenge the widespread assumption that women and traditionally female occupations go together. Unchallenged, the assumption becomes a self-fulfilling prophecy.

We have already mentioned the dearth of solid career exploration among women's centers' pre-employment programs, focusing as they did primarily on building women's self-confidence at the beginning of transition to paid employment. JTPA intake and counseling staff were no

41

more likely to expand women's occupational horizons. Most SDAs normally require participants to go through a day or two of orientation, but it typically focuses on job readiness skills such as interviewing and work habits. As the director of a JTPA intake agency told us,

> Most people pretty much know what they want to do, so there isn't much need for intensive vocational counseling. It's available if they want it.

This man also told us that his counselors "hardly ever talk about the money issues" with women because he thought that careers and wages were covered in an orientation session that prospective JTPA participants received before arriving at his intake center. We attended one of these orientation sessions; career exploration consisted of a tour of the vocational school where the session was held. The counselor who led the session did not address the wage aspect of different occupational areas at all.

One JTPA counselor assured us that because she distributed handouts listing all available training programs to clients, women's choice of female-intensive training programs had to be seen as a free choice. Several counselors said they asked women what they were "interested in," with women usually responding "clerical". Others said they advised women to choose programs on the basis of what they had done earlier. Since most women's jobs have been in female-intensive occupational areas, the results were predictable. Said one woman in clerical

training:

> Common sense told me that at my age [she was 57] I didn't
> have a lot of options. I'd already been in the office
> end of the work force, so probably my best bet would be
> to update my skills.

One woman, a JTPA participant who had spent her adult life as a

homemaker but was forced to seek work because her husband was laid off

from his job, wondered whether women who were unsure of their

occupational choice received the help they needed:

> I had the feeling, myself, that women who for one reason
> or another the staff decided were not highly enough
> motivated were weeded out in the beginning. But it
> seemed to me that they needed something extra. What I
> mean is, if someone comes in and says "I want some
> training, I want to get a job," and they look at her and
> say, "Exactly what do you want to do? How long will it
> take? How much will it cost?" well, most of the women I
> saw at the JTPA office have the desire to better
> themselves but they haven't thought it out like that.
> They need some help in doing that, not to be told to come
> back when they're more highly motivated.

Beyond the lack of an NTO requirement in the legislation and the

lack of career exploration on the part of women's centers and JTPA,

perhaps the most powerful influence to discourage nontraditional program

enrollments is the JTPA "Entered Employment Rate" performance standard,

or placement rate.

Training providers' contracts typically specify the placement rate they must achieve (the federal guideline is now 68 percent for adults, 56 percent for welfare recipients) within three months of a participant's "termination," or program completion, in order to be paid for their work. If a program's placement requirement is to place ten women, for example, and they place only five, the program can lose up to half its contract dollars depending on how payment is scheduled in the contract. Naturally, payment is highly motivating to training providers, especially since they have already incurred the costs. Similarly, SDAs must achieve their placement rate as an average of the individual training providers' rates. Any factor that makes participants harder to place therefore becomes something to be avoided.

Nontraditional occupations for women has to be near the top of the list of factors to be avoided since employer resistance to NTO women can make them hard to place. This puts training providers and SDAs alike into jeopardy. We heard a great deal about employers who refuse to hire women for NTO jobs. As the director of a woman's center with an OJT contract that emphasized NTO placements told us,

> They [employers] send us a letter saying "Please send us women so we can hire them for this project." We go through our files, find them, and refer them out, and none of them get hired. All the contractors want to do is show the government they made a "good faith effort." What that does is add to the frustration of women who go to apply, add to the staff's frustration in going through the files and finding people -- it's just a waste of time. So now when a contractor sends us a letter saying

they want women for nontraditional jobs, we just post it in the resource room and anyone interested can go and apply.

And the director of a vocational school with several male-intensive programs said,

> They [employers] don't come out and tell you. They find all the other excuses not to hire her. They find ways to do it. About once a year I get letters from a lot of these large corporations because they're not meeting their EEO requirements. It is just a nice letter that they show to the government, and the government says "Well, at least you're trying." But if you begin to refer women, they don't hire them. I have had this experience many times.

The same vocational school director told us about a woman who became a certified welder in his school and could not get a job because employers refused to hire her:

> Director: She was looking for a job probably 30 days already and she was beginning to feel really down. I told her, "You knew you were going to get into a tough area."
> Interviewer: Were the men from her class getting jobs?
> Director: Yes, yes. But ...
> Interviewer: Do you think she was being singled out because she was a woman?
> Director: I do believe so, yes. I have heard some rumors from employers that a woman at their place of employment in that kind of field would be a distraction to their people. They do a lot of bending, and supposedly this would create a distraction.

A women's center staff member told us that this sort of situation puts her in a trap. She knows perfectly well which companies refuse to

hire women for nontraditional jobs, but is sure that if she were to call a state or federal agency to report it the company would find out who called. In that case, she told us, she can forget about using that company ever again for placements.

Another performance standard that tends to keep women in traditionally female programs is the "Cost per Entered Employment" rate. Traditionally female training can often be accomplished relatively quickly, such as updating earlier clerical skills. This translates into a low cost-per-placement figure, desirable from the SDA's point of view.

> A JTPA counselor: Some of the women have an excellent background in clerical, so we offer them word processing. It doesn't take long for them to go to school and update their skills, then they're ready for the job market.

To illustrate the often dramatic difference between what SDAs are allowed to spend and what they actually do spend for training per person, the cost-per-placement standard in one SDA we visited was $4,891 in Program Year 1986-87, but their actual cost per placement was $1,996. To the extent that NTO for women takes more training and thus costs more than updating old clerical skills, the system rewards occupational segregation.

In view of how hard NTO is to do in JTPA, we asked a staff member of a women's center that tried to do NTO in its OJT program why she did it.

> Staff member: Because these jobs offer women more
> earning power. They pay better, so they give women
> more of a feeling of self-worth. The more money you
> make the better you feel about yourself and what
> you're doing. You're not dependent on anyone for
> anything.
> Interviewer: How come other women's centers around the
> country don't take this as seriously as you do?
> Staff member: I think it's because it's really hard to
> get into NTO. It's hard for a women's center, and
> it's hard for a job developer. You have to be
> extremely persistent. It takes a long time to work
> with somebody, a long time to get them in the door.
> If a woman has real minimal experience in
> nontraditional, it takes longer to place her, so it's
> not cost-effective to a grant.

It is easy to see how performance standards have discouraged training providers and SDAs from recruiting women for nontraditional occupations. However, JTPA has recently issued several new performance standards dealing with post-program followup. One would think that NTO women would be more likely to stay on the job than women in female-intensive jobs which pay lower wages, in which case the new performance standard in theory would serve to encourage NTO in the system. We shall see whether "adult entered employment rate" which discourages NTO or "adult followup employment rate" which may encourage it turns out to be more influential in program decisions with respect to NTO for women.

Short-Term Training

Short-term training is the rule in JTPA, partly because it is the intention of the system to move people into jobs quickly but especially

47

because of the "cost per entered employment," or cost per placement, performance standard. Short training costs less money than long training, and the lower the cost-per-placement figure the better for the SDA. While we found some nine-month training programs, more typical were these from one SDA we visited:

Six months: general office

Three months: industrial maintenance, electronic production.

Two months: clerical brush-up

Five weeks: child care provider, nurse assistant

We did not collect data on length of program by sex of participant, and thus do not know if short-term training was more of an issue for women or men. The minority opinion was that many women prefer short-term training over training that would last a year or two. It was best expressed by an SDA assistant director:

> From what I know about our participants, they don't have the time for two-year programs -- there are no stipends. Two years out of a person's life, particularly female who already has responsibilities with a family, the majority of them really don't want to be committed to a two-year or a four-year program. So if we can find the jobs where we can get them done in nine months, I think we've done women a real service.

While we can speculate on how women would feel about long-term training if there were stipends (which are discussed in the next chapter), we don't have to speculate at all on the high cost right now to women of

short-term training. There was ample testimony from many people on

this. For example:

> Women's center staff member: Women with associates
> degrees are getting low-wage jobs, so people with even
> less education are even more dead-ended out.
>
> JTPA woman who couldn't get a job after her clerical
> training: I couldn't build skills that I could fall back
> on because everything was happening too fast.
>
> Women's center staff member: We get a lot of women here
> **after** they've been in JTPA programs, when they don't get
> a job through JTPA and they're ineligible for any other
> program. Women come here who have had only eight weeks
> of training -- medical records, data entry. Most of them
> can't even build an adequate typing speed in eight weeks.
> They wouldn't be marketable for at least a year, and
> that's only if they have very good finger dexterity.
>
> JTPA woman a month out of training: I completed six
> months [of clerical training], which was all their
> funding allowed. Actually, had I stayed for another
> couple of classes I could have had a certificate or
> possibly even a two-year degree because I have been in
> college before. I'm not sure if that would have upped my
> chances for getting a job or not, but I'm inclined to
> think it probably would. I know that some of the women
> feel they're allowed only so many classes and then
> they're pushed out into the marketplace as quickly as
> possible without thinking ahead to how well prepared they
> actually are. In other words you can get a job at
> minimum wage, but if staying another quarter or even a
> whole year would prepare you for a much better job, then
> it would seem to me to be worthwhile to do that,
> especially for those who are supporting families. There
> is some resentment among women about this.

The awareness of the relation between short-term training and low

wages was widespread (low wages will be discussed in more detail in the

next section). What was less widespread was an understanding of how

short-term training made nontraditional occupations even harder to

achieve, for two reasons. For one, brush-up training obviously requires less time than training in an entirely new field. Another reason is that most women do not have the basic skills and do not know the technical vocabulary in such areas as mechanics or carpentry: they are not raised that way. An auto mechanics program for women, since it must begin at a more elementary level than most men need, can therefore be expected to last a little longer. The system thus has an incentive to produce male auto mechanics rather than female ones, especially when child care and other support costs are factored in: males cost less to train.

Low Wages

JTPA is not a system designed to make participants -- male or female -- rich. SDAs that gave us data on wage at placement reported an average of about $5 an hour for about 15,000 people. This is more or less at the level of the federal performance standard of $4.95, although state wage-at-placement standards vary slightly from the national standard.

However, there are low wages and there are even lower wages. When the wage figures are disaggregated by sex, women are seen to earn 52 cents an hour less than men: $5.24 for men and $4.72 for women. An examination of the average wages in five SDAs we visited that were paid

to women and men by occupational area is instructive:

Female and Male Wages by Occupational Area

Occupational Area (3-digit DOT code)	Women		Men	
	Percent	Wage	Percent	Wage
Total	100	$4.72	100	$5.24
Professional, technical, & managerial	10	5.16	8	6.90
Clerical and sales	43	4.68	11	5.26
Service	26	4.04	19	4.04
Agriculture, processing, & fishing	1	3.81	3	4.13
Processing (industry)	2	5.66	5	5.46
Machine trades	5	5.02	21	5.67
Benchwork (assembly)	8	4.57	8	5.14
Construction	2	5.63	14	6.00
Miscellaneous occupations	3	4.36	11	5.03

Among the conclusions that can be drawn from the data:

o Men out-earn women in seven of the nine occupational areas.

o The average wage for almost four-fifths of the men is $5 or more an hour. This is true for less than one-fifth of the women.

o Occupational segregation exacerbates the wage gap between women and men, since most women are concentrated in low-paying clerical/sales and service areas.

These SDAs also gave us data on wage increases for those participants who had worked before enrolling in JTPA:

Wage Gain, Pre/Post JTPA			
	Pre-JTPA wage	Post-JTPA wage	Gain
Men	$5.31	$5.50	19 cents
Women	$4.33	$4.78	45 cents

The greater wage gain figure for women is occasionally cited as proof of JTPA's greater effectiveness for women, as it was with CETA. We think this is disingenuous, however, when women earn so much less **after** JTPA job training than men **before** it. One buys groceries with money, not with wage gain figures.

To put all these figures in perspective, imagine a woman who earns the female JTPA average of $4.72 an hour. Assuming a 35-hour work week, 52 paid weeks a year, and take-home pay at 80 percent of gross pay, this woman would take home only $6,872 per year, or $132.15 per week. One cannot very well support a family on $132.15 per week.

Women's center staff members, when asked to estimate what women would need to earn to support families at a subsistence level, consistently answered between $7 and $8 an hour. In fact, there was widespread awareness from everyone we interviewed that JTPA wages are insufficient to live on.

> Women's center staff: I don't think you can earn more
> than $5 an hour in a clerical job, and I don't think this

is enough to live on.

The interviewer asked a woman who expected to make $5.00 or $5.50 after her clerical program whether she could live on that:

> Woman: No, I know I can't, not until I work myself up.
> Interviewer: How are you going to live in the meantime?
> Woman: Well, right now my parents are helping me. My mother is taking care of my kids.
> Interviewer: And if you didn't have your parents to help you?
> Woman: I know. I would be in a very hard position. I wouldn't probably be able to go to school and I'd probably end up getting welfare. I know plenty of women like this. There's a lot of them that don't have no skills. What do they do? They're on welfare. That's the only thing left.

We often spoke to women who simply refused to believe they'd actually earn so little, despite being told:

> Interviewer: What will you make when you're finished [your clerical program]?
> Woman: They're talking about $4.50 an hour.
> Interviewer: Can you manage with that?
> Woman: Oh, I'm sure I'll be able to make more than that.
> Interviewer: Why?
> Woman: I'm determined enough to look and find something that will pay me more than that. I've had job offers making that much money without any skills.
> Interviewer: If you can only find jobs at $4.50 an hour, what will you do? Can you live on that?
> Woman: I seriously doubt I could.
>
> Interviewer: What will you earn when you finish [clerical] training?
> Woman: They told me $4.50 an hour.
> Interviewer: Can you live on that?
> Woman: Honestly?
> Interviewer: Yes.
> Woman: No, I can't.

Interviewer: So why are you doing this?
Woman: Because I can use these skills and whatever other skills I had and try and get a better job.
Interviewer: What's going to happen if in fact you can't do better than $4.50 an hour?
Woman: I'll have to survive. I really think I can. I'm really confident I can. Because I'm going to do my best, and when I get out there my skills will be better than $4.50 an hour. And I guess my mind's made up so much that I know what I want and I'm just going to go and get it.

These women seemed to think that their wage level was entirely in their control. In believing that getting a better-paying job depended on themselves, not succeeding would be similarly personalized. It disturbed us very much that these women were likely to blame themselves and not the job market for their inability to find a job that paid a living wage. They would perceive the experience as just one more personal failure in a long line of failures.

The issue of low pay often came up when discussing the clerical careers so many JTPA women were preparing for. An assistant SDA director, a woman, told us:

There's no reason why clerical positions should start as low as they do. We get job orders for clerical and then when they say the wage you want to laugh at them. They'll want an executive secretary for $5 an hour, and those positions should be going for $1,500 a month for what they're asking for. Even a receptionist -- you can't pay a receptionist $4 an hour. This is a demanding position, the person who first sees the public. You've got to pay for that. I guess I'm talking about comparable worth.

And just as often, when people talked about low wages they talked about welfare.

> Women's center staff: Even in [state] where welfare is so low, when you begin to add up the other things involved, for instance subsidized housing, food stamps, Medicaid -- even though the spending money is only $150 or $200 a month, a woman cannot in a million years get a job at $4 an hour or even $5 an hour and cover all those things. So what are we offering this woman? We're telling her to get a job and be independent, but she's worse off now than she was before. And in states that pay much nicer benefits she's really worse off.

> JTPA counselor: Low-wage jobs are a big problem for women. A young woman can go through training and can get a job, and then if her salary is not adequate she can't pay her day care or transportation. But they've taken her off welfare and she can't manage.

> Women's center staff: It's hard for a woman to get off welfare. Let's say she's living in subsidized housing, a dump, for $35 a week. She can justify living in that dump. But if she gets off welfare, no training to speak of, and gets a job for $3.75 an hour, the $35 apartment jumps to $100. Now she's living in the same dump but paying $100 for it. She now has less money available than she did when she was on welfare so she can't go out and find a better place. So she works all this out in her own thinking -- she's not stupid, after all -- and naturally she stays on welfare. There's no incentive to get a job.

In one state we visited, we were told that a woman with one child receives $511 in welfare, $94 in food stamps, and free health insurance each month, with no child care costs. While this does not make for a high standard of living by any means, typical JTPA jobs do not pay that well. There was general understanding that many women cannot afford to leave welfare for the low-wage jobs available through JTPA, not out of

any psychological sense of dependence but economically in the sense of a woman's ability to pay for child care, transportation, and health insurance. These will be discussed in the next chapter on support services.

If there was such widespread agreement over the financial hardships women face in low-wage jobs, why were they so prevalent? We were given a number of explanations. We were told that area wage scales were generally depressed, and that JTPA-type jobs are simply not worth more than $4 or $5 an hour. We were told that women make less than men because they have less work history. We were told that low wages were inevitable in view of the pressure for short-term training imposed by the cost-per-placement performance standard. One person even told us that although women's wages were low, that wasn't important: self esteem was more important than high pay.

The most common explanation, however, and the "official" one as it were, is that the system is designed to provide JTPA completers with entry-level jobs.

> SDA assistant director: I think our Private Industry Council believes that we give people starts and that we will take them to a certain point, but then they're responsible for their education.
>
> JTPA counselor: I explain to them [clients] that our training is entry-level. It's a short type of training where they can make a step and do something for a start. This is a stepping stone. You learn entry-level skills

so you can go out and find a job, and then you go up from there.

JTPA official, Employment and Training Administration, referring to the average-wage-at-placement performance standard of $4.95: The figure is low, but on the other hand the jobs are entry level. It's probably okay for a start.

There were, of course, women who completed JTPA training, obtained poorly paying jobs, and hung in long enough to earn decent wages exactly as it is hoped they would. We have quoted some of them in this report. It would seem, however, that the average JTPA woman who is trying to support herself plus one or more small children on take-home pay of $132.15 every Friday cannot possibly manage unless she has unusual resources such as free child care or free rent from relatives, and even then it would be touch-and-go for a while.

Moreover, nearly everyone we spoke with agreed that in all but the minority of married-couple families served by JTPA, women rather than men were responsible for raising -- and supporting -- children. Women therefore need higher job wages than men, but are getting lower wages.

We are happy to be able to present in this report one instance of an SDA that was not content with an unusually large male/female wage gap. The deputy director of the SDA recognized the low female wage and decided it was not acceptable. In order to make her staff realize she was serious about the need to close a wage gap of nearly a dollar an hour between adult men and women, about a year ago she announced that

henceforth one of several elements of staff performance appraisals for line supervisors would be the extent to which they could raise women's wage at placement. Bonuses of from $350 to $1,100 were awarded for excellent performance appraisals, with the funds coming partially from incentive award money and partially from the regular administrative allocation. As of this writing, she reports that the male/female wage gap for adults has shrunk in a year from $1.00 to 28 cents an hour. Similarly, the male/female wage gap for youth has decreased from 30 cents to 3 cents an hour. Breaking our anonymity rule in this case, the SDA is in Fort Wayne, Indiana; the deputy director is Ms. Betty Lou Nault.

Even this wonderful story, however, has its not-so-wonderful side. Men in this SDA are now earning an average of $5.27 an hour, while women are earning $4.99. As we have seen, $4.99 is not enough to support families on.

In this chapter we have discussed how the performance standards for placement and cost per placement encourage the JTPA system to select those participants who are likeliest to be placed. They favor the job-ready over those needing job training, those who need little training over those who need more, and sex-traditional job placements over nontraditional job placements. In the next chapter we explore another aspect of creaming: how support services also serve as a filter for those who receive JTPA assistance.

- - THREE - -

SUPPORT SERVICES AND JOB BENEFITS

IN THIS CHAPTER

Child Care
Transportation
Sickness and Health Insurance
Stipends While in Training
Saving Money on Support Services

Child care

Nearly all the women we interviewed -- 27 out of 31 -- were supporting dependents, in most cases small children. A few women were supporting unemployed or disabled husbands as well. About twenty were single mothers with young children; they were solely responsible for raising their children, although a few received limited financial support from fathers. Once again, we were struck by how readily everyone seemed to assume that "a single parent" was necessarily the mother, as if children of single mothers have only one parent. No question about the fact that child care, under these circumstances,

becomes a woman's issue.

All but one of the SDAs we visited paid for child care while women were in training, and several also paid child care costs for the beginning of employment. Nearly everyone we talked to, including JTPA officials, recognized the critical importance of child care if women were to move successfully into paid employment. An assistant SDA director emphasized her SDA's commitment, saying that it paid full child care costs throughout training and for the first two months after placement, no matter how many children women may have:

> I think we're probably one of the few Service Delivery Areas in the state that pays child care to the degree that we do. Why? It's a commitment to serving women. We just know that since we have to serve 60 percent females, that's what they need to go through training.

She told us that the SDA was in the process of trying to get the welfare department to share some of the child care costs because it is so expensive: "It's getting to the point where either we train people or we pay for child care." Two other SDAs similarly mentioned the strain on their budgets from paying the high cost of child care.

The only SDA with a policy not to pay for child care at all made this decision a couple of years earlier at the suggestion, ironically, of a women's center director who at that time was new to her position (the same one we mentioned earlier in relation to a cancelled NTO

60

contract). She felt women did not make use of JTPA child care money when it was available, and concluded that they did not need it. To evaluate her suggestion to stop paying for child care, the SDA director analyzed the reasons people gave for dropping out of the program and found very few specifying child care. He thus concluded she was correct, partly because welfare covers the cost for women on AFDC. At the time of our interviews, both of them still believed the decision was correct and for the same reason: according to each of them, they heard no protests about it.

> SDA director: No one has ever complained at the public hearings when we hold them every two years.
>
> Women's center director: Child care doesn't come up as an issue. My staff doesn't bring it up with me, and they also don't bring me requests for child care.

At this SDA we spoke with a woman whose child care costs were paid by the welfare department while she was in training. When we told her about the local belief that child care is not needed, she exploded in indignation:

> Ha! That's ridiculous! Obviously women don't tell them they have child care problems. They might be like me maybe, saying "Well, this is my problem, I'll handle it." But that's ridiculous. Child care is the biggest problem of any working woman I know. Even women who are working and making good money still catch it. If it wasn't for their relatives, I don't know what they'd do. And the relatives can't always help -- some grandmothers don't like kids, or they don't have time, or don't want to be bothered, or they're working themselves.

This SDA, however, was really an aberration. There was another that put a temporary freeze on child care payments when its budget was exhausted, but in general SDAs went to considerable expense to cover child care during training and even for a few months into employment. Nevertheless, child care still surfaced as a very serious problem according to women in JTPA and women's center staff. They mentioned ten major areas of difficulty connected with child care, even when JTPA paid for it, that interfered with a mother's ability to complete her training or to enter or stay in a job:

1. It is difficult to find openings -- there are long waiting lists.

2. Some child care centers have age restrictions, especially on infants and school-age children.

3. One SDA paid child care only for time actually spent in classrooms. The time a woman spent getting from the child care center to the classroom and back again was not covered, and this can amount to two hours a day. For a low-income woman, the cost can be prohibitive.

4. Vocational schools often start classes quite early in the morning, and a woman can have a hard time finding someone to watch her children for an hour at 7 AM and to take them to the day care center when it opens at 8 AM.

5. Reimbursement checks for child care sometimes take up to two months to come through, and few babysitters or child care centers can afford to wait that long to be paid. This was a very common complaint.

6. In the SDA that did not pay child care, women paid a psychological toll for asking family members to care for their children. As a women's center staff member said,

> Women whose family members are available to babysit aren't really so lucky. The situation forces them to ask for a favor and be dependent, which is tough when they're trying to be independent. They feel bad having to ask, but with no child care money they have to do it.

6. In one SDA, women in OJT training were not eligible to receive child care because they were seen as "wage earners" and thus supposedly able to afford it on their own.

7. In another SDA JTPA pays $5 per day per child, but the cheapest minimum rate available in that town is $10 per day per child.

8. When children are sick, day care centers (and babysitters who take care of other children as well) refuse to accept them. If a mother can't find a neighbor or relative to stay with her sick child she is forced to choose between leaving the child home alone or missing class. Many classroom programs have rigid rules about absences, and

several women told us they did not complete their programs because of absences caused by sick children.

9. While some SDAs paid child care into the employment period, in most the benefit ended with the completion of the job training program. Child care was therefore a problem during the job search period and until the first paycheck.

10. Child care was an unmet need during the intake period in every SDA we visited. JTPA is permitted to pay for child care only for enrolled participants, and by definition no one is enrolled yet at intake. None of the four centralized intake centers we visited had even a play area for children.

What these informants were telling us, in effect, is that child care is a chain that is only as strong as its weakest link.

Given the pressure to meet performance standards, SDA staff are essentially forced to accept those people who are most likely to complete training quickly (meaning cheaply) and be placed in jobs paying somewhat more than minimum wage -- in other words, people who will do well in performance-standard terms. Assessing that likelihood accurately is therefore of prime importance. Child care can be a significant element in JTPA's decision about enrolling an individual, both because of its cost and its relation to placement prospects.

Sometimes women with small children are turned away at the intake/assessment stage. A JTPA intake counselor said:

> We also take into consideration the amount of children they have and their ages and so on, because we want them to be successful. This information can be barriers or obstacles, to the point that they would not be able to attend school. We do provide child care, but for instance -- say a woman comes in, maybe has four children, three of them are before school age. We know that this many kids have a lot of problems, a lot a colds, illnesses, and so on. It's very difficult for this woman to leave those children, to continue her training or even do a job search. Sometimes we say to her, "Maybe the time isn't right now, at this particular time."

We asked an SDA director if she thought women with high child care needs were ever turned down in her SDA:

> I can't prove it, but I would think there would be some of that going on. A woman with four children is a high-risk person -- hard to keep in training, expensive to keep in training, hard to place, and hard to retain.

Both these people stressed that in their SDAs most women with small children are not routinely turned away on that account, but agreed that if someone is to be turned away for child care reasons it is likelier to be a woman than a man.

The women we interviewed at the SDA that temporarily ran out of child care money told us how the intake personnel screened out women with child care needs. One woman, who was raising her two-year-old at

her parents' home after fleeing from an abusive husband, said:

> The woman who's in charge of our school made it perfectly
> clear that JTPA did not want to accept anyone they had to
> help pay for child care or transportation. So I was darn
> well going to do it on my own.
> Interviewer: What did you do for child care in the
> meantime?
> Woman: My mother was going to work but she thought it was
> more important that I go to school. She watches my son.
> It's pretty tight.

One SDA we visited had been paying 100 percent of child care for two months into paid employment, then gradually phased out the subsidy over a few more months. SDA officials decided to cut back on this generous child care policy when they realized that many women were quitting their jobs at the end of the subsidy when they could not afford to pay all of it themselves. Some women even quit their jobs when the subsidy was reduced from 100 percent to 75 percent. There really isn't much sense to a time-limited child care subsidy if women can't earn enough to pay the bill on their own before the subsidy runs out.

Several SDAs spoke to us about their concern about women refusing to take low-wage jobs upon completion of training or quitting soon after starting work, when the women discover they are not earning enough to afford the high cost of child care. Such outcomes hurt performance standards. Some SDAs have worked out systems to head off this possibility at the intake stage. One intake counselor showed us worksheets used with all prospective trainees with dependent children.

With the worksheets as a guide, women figured out their monthly budget, including child care, calculated how much pay they would probably take home every month from a typical job in the field they chose, and finally worked out whether they could afford child care (estimated locally at $270 per month per child), to see if they could cover their expenses.

> Interviewer: If you do the arithmetic, it looks like a woman who is making $4.75 an hour has no way to get off welfare, right?
> Intake counselor: Yes, that's the reality of it. That's why we try to project whether she can afford to enter training.

An SDA director put the issue more bluntly:

> The cost of child care is unreal. Even with an average placement of $6.00 an hour, if a woman has two children her child care is going to run her anywhere from $400 to $500 a month. [We then figured out the take-home pay at this wage: $831 a month, obviously not enough to pay that kind of child care.] So when we work with clients we explore with them what other resources they have to draw on: "If you're going to be working at this $5-an-hour job, what other income and resources do you have that will assist you in making ends meet?" Because we know that if we place her at $6.00 an hour and she has two kids, she's not going to make ends meet. In order for the placement to work, the person needs to come out ahead. And eventually she'll see that she's better off on AFDC than she would be in a job.

Indeed, virtually all women's center staff and JTPA staff members we spoke with, when pressed on the cost-of-child-care issue, agreed that unless women had special resources such as free child care or free rent, the low JTPA job wages usually meant that they just could not afford to

leave the welfare rolls. One ironic conversation we had in this regard was with an associate dean at a community college with several JTPA training contracts, one of which was to train child care workers. The dean said that the main difficulty was that child care jobs paid so poorly that women in those jobs couldn't earn enough to pay the child care bills for their own children while they were working as child care workers.

If women with high child care expenses were less likely to make it through intake and become enrolled in JTPA than people without such expenses, we can only speculate about the women who didn't even make it to the intake stage. We asked many JTPA informants what they knew about presumably eligible people who didn't respond to recruitment efforts, on the hunch that lack of child care during intake would be more likely to prevent a woman than a man from making a first contact with JTPA. We didn't expect an SDA to have done a study on this question and none had, but we were disappointed that few informants had even thought about it. Basically, their position was that "no complaint" meant "no problem."

Given these circumstances, one can't help speculating about the stereotype of the woman on welfare who has many children to boost her welfare check. Perhaps it works the other way around: perhaps women who have many children must stay on welfare because the lack of affordable child care leaves them with no way out of the welfare system.

Transportation

Transportation was mentioned almost as often as child care as a problem by every category of person we spoke with: JTPA women, women's center staff, and JTPA staff. Even more than child care, transportation was a support cost paid by all SDAs we visited without exception. They did so by providing public transportation passes or tokens or fares, and in rural areas with no public transportation they gave mileage allowances or reimbursed drivers for the cost of gas. Problems, however, were legion:

1. Many people mentioned inconvenient hours for public transportation, such as when the buses and the classes both started at 7 AM.

2. Bus routes were far from women's homes, or from school, or from potential jobs. Several people told us that this was especially a problem in lower-income areas, and of course this is where JTPA-eligible people are likely to live.

3. Buses were scheduled to run as infrequently as once an hour, causing some women who had to make connections a commute of a couple of hours or more.

4. There was no public transportation available in rural areas. Carpooling seemed to be the only alternative, and it was notoriously

unreliable.

5. The transportation allowance paid less than actual costs.

6. There was a long delay in reimbursement, and it was impossible for trainees to advance the money.

Several people mentioned that women have more difficulties with transportation than men. Women are less likely than men to have cars -- they earn less money and thus are less able to afford to buy a car or have it repaired. Women are less likely to have the mechanical skills that would spare them from having to pay someone else to do routine maintenance on a car. In married couples with one car, the husband usually has priority. An SDA director pointed out that women have more problems than men not only with private cars but with public transportation as well:

> Transportation is more of an issue for women than men primarily because most of the women we work with are heads of household. That means they have to take the kids along when they have to go someplace. The men we serve either don't have kids or they're married and they have a spouse to take care of that, so all they need to worry about is getting themselves from A to B.

A women's center staff member pointed to transportation as an example of why it was essential to have someone available to help women resolve problems that come up. She told us about a woman on an OJT

placement in a rural area who was doing fine until her car broke down. With no way to get to work and no money to fix the car, the woman quit her job. The staff member found out about it in a routine phone call. She got the car fixed with contract support funds and arranged for the woman to get her job back. If it hadn't been for the women's center, a transportation problem would have kept this woman from finishing her training.

Sickness and Health Insurance

"Lots of times these women have just had one kind of tragedy in their life after another." This observation by a JTPA counselor was borne out by the women we interviewed for this project. We met only 31 women JTPA participants and certainly did not press them on details of their personal lives, but they mentioned all of the following as having occurred to them recently: two surgical operations, a broken collarbone, a uterine tumor, bronchitis, pneumonia, an auto accident, several cases of the flu, multiple injuries received in beatings from an abusive husband, allergies, a foot tumor, and breast cancer. And this was just the women themselves. Their children were frequently at the doctor's with ear infections, injuries caused by accidents, chicken pox, and other childhood illnesses and accidents.

We visited no SDA that provided health insurance, although doing so would be an allowable expense. As with child care, we do not know how many otherwise eligible low-income women who do not have Medicaid are discouraged from seeking job training through JTPA because of the lack of health insurance while in training. And we do not know how many women feel forced to go directly into the job market with inadequate skills out of an urgent need for health insurance.

There is no doubt, however, that as one women's center staff member put it, health insurance is a "biggie for women." The fact that women on welfare automatically receive Medicaid and that many low-wage jobs, especially those with small businesses, do not provide health insurance as an employment benefit operates no less surely than child care to keep women who would prefer to work restricted to the welfare system.

> A woman's center director: Some women won't even accept a job if it doesn't have health benefits, and I can't blame them. Especially if you have two or three kids and you get cut off welfare, if you're taking a job that pays $5 an hour and no health benefits for your kids, well, I wouldn't choose differently myself.

Another women's center director pointed out that in comparison with Medicaid, which pays 100 percent of medical bills, even good health insurance benefits pose a problem for low-income women:

> You have to remember that the very best insurance policy only pays 80 percent. When a woman making a low wage thinks of the seriousness of having three children who

might have their appendix out, who might fall out of a
tree, she has to stay on welfare. Or maybe she gets a
slightly better job and is doing okay, but the minute
something comes up -- either she gets sick or the kids
get sick or somebody has an accident -- then that's it
because she has absolutely no margin for paying 20
percent of a big bill.

And, we might add, she would probably have to pay 100 percent of the
bill up front and wait to be reimbursed by the insurance company for 80
percent of it, which even fewer low-income women can manage to do.

One of the women we interviewed who had not been on welfare was now
working for $5.19 an hour in a clerical position and supporting her 9-
and 10-year-old children; her disabled mother provided free child care.
Because she couldn't afford to pay $60 a month to participate in her
employer's health insurance plan, she also worked nights and weekends as
an usher at local basketball games: the union offered health insurance
at only $5 a month. She was able to see her children only for part of
the time on weekends, and was so stressed that she wept when we
interviewed her.

Indeed, the lack of benefits in the jobs these women were getting
after JTPA was a subject that came up again and again, often but not
always in connection with part-time jobs that women were forced to take
when full-time jobs were not available. We were repeatedly told about
new stores opening up that hired all staff on a part-time basis with no
benefits. We interviewed a woman who pieced together three part-time

jobs in order to support herself and her children; none paid benefits.

A woman's center staff member who ran an OJT program provided details:

> I have employers who don't want to hire full time because
> that means they'll have to pay benefits. It's cheaper
> for them to hire part-time employees. And it's not only
> small employers -- Sears hires all their folks that way,
> Montgomery Ward, a lot of insurance companies. And who
> do they hire? Women. Clerical jobs. Retail sales jobs.
> And those are women. I see a lot of women who have to
> work two jobs in order to make ends meet.

An SDA director mentioned that some local employers were beginning to
offer "cafeteria-plan" benefits which, although touted as a great
advance, did not solve women's benefit problems. In effect, such plans
force single mothers to choose between essential benefits such as child
care and health insurance. Two-parent families, she pointed out, in
effect can have double the number of choices a single-parent family can.

Although we did not study men in JTPA, men may not be doing much
better in the benefit department than women. As one SDA official told
us, men were typically getting jobs "with small employers, with no
benefits." However, since women are far more likely to be responsible
for children, the lack of benefits, especially health insurance, falls
far more heavily on them.

Stipends While in Training

Unlike CETA before it, JTPA does not pay stipends to participants while in training, and we heard some comment about this from people who had been involved with both programs and were thus able to compare. The first and most obvious consequence of the no-stipend policy is that it favors women who have financial resources: women on welfare and women who are being supported by husbands or ex-husbands.

The 31 JTPA women we interviewed followed this pattern. Eighteen of them were on welfare and seven others were entirely supported by husbands or ex-husbands. The remaining six women pieced together money to live on from multiple sources: ex-husbands, savings from previous jobs, unemployment insurance, and parents.

We were told that women who are not on welfare often pressure JTPA for short training programs because they cannot afford to be without an income for long. One SDA helped non-welfare recipients to make it through training by finding them part-time jobs:

> SDA director: I'd guess that fifty to sixty percent of
> the people at the skills center are employed part-time.
> We went to a ten-hour day, four-day week there so that
> people could pick up part-time jobs.

Part-time jobs in lieu of stipends, however, are of limited usefulness to single mothers who must be home to care for their children. It is

perhaps not a coincidence that this SDA director was referring to a JTPA-supported vocational school that enrolled primarily men in its mostly male-intensive programs.

Several people we spoke with felt that the lack of stipends was a serious drawback, even for women receiving welfare benefits:

> JTPA counselor: Stipends made it easier for women. It's so hard now for a woman who has children -- how does she pay her bills? If a woman chooses to go to school she can apply for a Pell grant, but then she often gets into trouble with welfare and food stamps and then ends up with even more financial pressures.

> Women's center staff member: Stipends are much better for women's self esteem and self confidence than welfare payments are.

In general, though, we did not hear about stipends nearly as much as we did about child care, transportation, or health insurance. We do not know if this is because the lack of stipends is genuinely not as much of a problem, or conversely that it is so much of a problem that women's center and JTPA staff do not even get to see women who need stipends to participate in the program.

Saving Money on Support Services

The law permits SDAs to provide support services to clients as long as the two general conditions are met: that doing so does not cause the

SDA to spend more than fifteen percent of its allocation (unless it has a waiver and can spend more), and that the expenditure occurs during training and/or not longer than six months after training. SDAs that can demonstrate that their clients, to benefit from training, require more support services than 15 percent permit, or that child care and transportation are especially expensive, can apply to their states for a waiver of the limit. No SDA we visited had requested a waiver.

It was surprisingly difficult to pin down how much of SDA allocations were spent for support services. Several SDA people told us they didn't know, and a couple of others "guesstimated." In others with firmer figures, the range was between three percent and 15 percent. While it was hard for us to take this kind of ignorance at face value, we had no independent way of getting accurate information. We found widely varying commitments to spending money on support services, from none at all for a need as fundamental as child care, to payments for interview clothes and emergency rent. In one SDA, a women's center that emphasizes preparing women for nontraditional careers had tools in six trades available to loan out until NTO women could afford to buy their own.

We have already discussed the pressure on SDAs to keep the cost per placement down as far as possible in order to be eligible for incentive money awarded for exceeding performance standards. One women's center, for example, told us of submitting a proposal to JTPA in conjunction

with a community college to provide job training to a group of battered women. Because the support service component was so expensive -- child care, sheltered housing in a former motel, and counseling, all essential services for battered women -- the SDA turned it down.

To the extent an SDA or individual JTPA contractors can manage to select people who meet the income eligibility guidelines but nevertheless need few or no support services, an SDA can lower its cost per placement. This type of creaming was demonstrated in the section on child care earlier in this chapter, and occurs mostly on a nonsystematic basis throughout the system. Another way to lower cost per placement by not spending money for support services is for the SDA to use the support service budgets of other local agencies. Indeed, several SDAs told us that the support service situation wasn't as bad as it looked because they aggressively sought and obtained interagency cooperation. When support service expenditures show up on the budgets of other agencies, of course, there is no way to determine whether JTPA women's support service needs are being met by examining SDA records.

According to the law, money up to the 15 percent limit that remains unspent on support services may be reassigned to training. The director of the SDA that did not pay child care told us he kept his support services expenditures down to about five percent quite deliberately in order to increase by ten percent the amount of money available for training, which was spent serving more people rather than spending more

money per person. Not spending available support money, he told us, was a local value with a long history: the PIC under CETA did not pay for stipends even though they were allowed. "We are paying what is demanded of us," said the SDA director, pointing out that part of the women's center's contract was to provide support services to clients in the entire SDA. What he did not say was that the SDA served approximately 1,400 clients per year and that the center was required to provide only 35 instances of support services per year on a request basis, at a total cost of $1,000.

According to another SDA director, support service creaming can be a serious abuse in fixed unit price contracts. This type of contract does not break out training costs (which can be known in advance) vs. support service costs (which cannot: when a contractor submits a proposal for funding, clients to be served have not yet been identified and therefore the contractor can only estimate the support services they will need).

> Interviewer: If a program operator [contractor] doesn't spend all of the allocation for support services, do they keep the unspent money?
> SDA director: In a performance-based contract, I don't really know because they come in with a unit price. If they forecast that the unit price is going to be $2,500 [per person] and they don't take anybody in who needs child care, they don't spend that, so that money stays with them.
> Interviewer: Has that ever been an issue? We can both see what the implication of that is.
> SDA director: Yes, it's been an issue, and it's one we're starting to address.

A women's center staff member in that town confirmed the problem:

> All the programs are supposed to have X amount of dollars they allocate for support services. But if they don't spend that in support services, they keep it. So we've had instances where we've had a woman in a work experience program or classroom training call us and ask US to assist her with her child care. We had to tell the client that the program she was enrolled in should be providing the child care for her.

In effect, a JTPA training provider working under a fixed unit price contract has every incentive to cream -- to accept only those people who need few or no support services, or if that is not possible then to farm out the support services elsewhere. Since women are supporting the children and since they tend to be poorer than men, in their greater need for support services they would be the most harmed. Moreover, there would be little for a training provider to fear from an adverse reaction from the SDA the following year, since the provider is not obligated to submit documentation on whether the money was spent for training or support services. This abuse is simple to curb by requiring that support service and training costs be specified.

Beyond these considerations, we would like to emphasize that the flip side of the importance of support services to women is that when support services are insufficient or not provided at all, women probably hear about it through word of mouth from their friends and relatives. It may be enough to discourage them from making a first contact with JTPA. In other words, people with relatively few support service needs may be overrepresented in JTPA and in this respect the system may be

passively discouraging those most in need of help. We were concerned about the characteristics and needs of the "invisible" JTPA-eligible population and asked frequently about it. No one knew.

- - FOUR - -

ADMINISTRATION ISSUES

IN THIS CHAPTER

Recruiting Program Participants
Reimbursement and Cash Flow
Data Collection and Distribution
Female vs. Male Leadership in JTPA

Recruiting Program Participants

The determination of which participants wind up in which JTPA programs is one with several components. There is outreach, or publicity, to potential participants; screening for eligibility according to JTPA guidelines on income and residence status, a paperwork task; assessment of participants' experience, abilities, and interests; and selection of a training provider or an activity such as Job Search. SDAs vary in whether these responsiblities are carried out entirely by a centralized intake agency, entirely by training providers, or shared by the two.

We visited four centralized intake agencies among our 15 sites. Several women's centers reported severe problems when they had to accept women recruited for their programs by centralized JTPA intake agencies rather than conduct their own recruiting. Their complaints centered on insufficient and inappropriate referrals from JTPA.

For example, one center with a pre-employment/job search program charged that the intake center sent them "all the women that were the hardest to place," with multiple and severe barriers to employment. When the center consequently was unable to place as many women as required, the SDA responded the following year by eliminating placement from the center's contract and cutting funds for a job placement counselor. Center staff members were adamant in insisting that their poor placement record was the fault of the intake center's referral choices.

Another center that in the past had conducted a JTPA-funded electronics training program found that the women sent over by the intake center "did not have the standards to be in a program like this." According to the participants, intake counselors had not told them they were being referred to a women's center or to a nontraditional training program. Staff found them to have more employment barriers than normal for the JTPA-eligible population, with many incidents of mental health, substance abuse, and other problems. The center asked to recruit its own participants, but was told this was not allowed. It then offered to

84

make a presentation to intake counselors on its program and participant requirements, but told us that the contact was not welcomed by JTPA. Desperate for participants, without whom of course the center could not meet its performance standards at all, the staff accepted women who probably could not make it through the program. Many didn't. The center failed to meet its performance standards, particularly placement, and thus did not receive a significant amount of its contract payment. "Financially, we took a real bath," said the center director. Without the ability to do its own recruiting, the center has chosen not to reapply for JTPA funding.

In one of the SDAs we visited, each of the five women we interviewed there said that they were referred from the intake agency to the women's center without any information on its program, which happened to be an OJT program.

Even pre-employment programs without placement requirements and without performance standards to meet suffered from centralized intake problems. A women's center had a contract for nine overlapping cycles of a 15-week part-time pre-employment program. The center found that with the intake center doing all the screening and referring, there were only enough women for four cycles. A request to do their own outreach was turned down. A request that the intake center intensify its outreach in the outlying areas of the county was not successful. As a result, JTPA did not pay the center about $20,000 in contract funds for

85

the five cycles that were not conducted.

By contrast, the center we visited that was most successful in JTPA terms -- it had half a dozen contracts of various types and was able with long experience to "make money on JTPA" (see the next section on how they did it) -- felt that a critical element of their success was the ability to do their own recruitment, particularly, they said, "for programs serving special populations" such as women. Individual contractor recruiting was an SDA policy there, with contractors sending likely participants on to JTPA only for certification. The center's associate director pointed out that since typical contracts have a partial-payment structure (partial payments for enrollment, completion, placement, etc.), an early dropout causes a program to lose all subsequent money for that person. Careful screening is thus critical to ensure a high success rate. "Not doing our own recruiting would be disastrous for us," she said.

We would like to emphasize that there was no way for us to verify these accounts, so a difference of opinion over what actually happened in these cases is possible. The central point, however, remains: when an agency has monopoly control over the recruitment and referral of participants, training providers are powerless to affect the decision on whom -- or how many -- they will serve. It is at least theoretically possible for an intake center, for whatever reason (perhaps in opposition to special programs for women, dislike for the director of

the women's center, or just garden-variety bureaucratic inertia) to strangle a center's program by cutting off its supply of participants or sending the wrong ones. Attention needs to be paid to this problem.

Reimbursement and Cash Flow

JTPA money isn't a problem for all training providers. The president of a private non-profit business college told us his school has a $16,000 contract to train 130 people, which works out to $123 per person. This is virtually free. He explained that JTPA students get Pell grants to cover half their tuition, books, and fees, and state tuition grants to cover the other half. The JTPA money is reserved for people who don't qualify for these two grants in time for the start of school in the fall, if there are any. "JTPA is good for us," he said. "It brings us people we wouldn't normally get."

The women's center that consistently earns money on its multiple JTPA contracts does so through two mechanisms. First, its SDA gives bonuses to performance-based contractors for exceeding their placement goals. Not all SDAs, however, distribute the incentive award funds they receive from the state for exceeding performance standards back to the invidual contractors who actually earned the award. Second, contractors in that SDA are allowed to include a "profit/risk margin" of about five percent of the full unit cost of training into their budgets, to serve

87

as a cushion in the event that performance goals are not reached. A contractor that meets its goals thus earns five percent extra.

Even this women's center, successful as it is with JTPA, has had its money problems. Payment delays were so serious at one point that the center could not meet its payroll without an urgent request to JTPA for immediate payment. This center did not indicate, however, that payment delays were more serious for them as a women's organization than they would be for other community-based organizations.

Performance-based contracting affects cash flow, which has other consequences. A women's center staff member explained that performance-based contracting encourages short training programs over long ones because payments are typically linked to program benchmarks such as enrollment, completion, and placement. The shorter the program, the less time between payments and thus the fewer cash flow problems a training provider will have. Moreover, this in turn affects the provision of support services, which can affect programs serving women more than others. She explained as follows:

> This payment structure hurts organizations that provide more support services for their clients. You have to have the cash flow, so if you have a client coming in who needs something like child care or something else, well, do you have the money right now? If you have long-term contracts and you don't get a large part of your reimbursement until the end of the contract, then you may not have the money for the supportive services the woman needs when she needs them. We do a lot of juggling to

find this money because we are a strong advocate for women. Other programs that may not be as sensitive might not provide the support services because of the cash flow problems.

Data Collection and Distribution

We visited ten SDA offices in our site visits to women's centers and asked each one for data on Title IIA adults that we thought was fairly fundamental: for the latest Program Year, July 1986 - June 1987, the following items for men in the SDA, women in the SDA, and if possible the women who had been through the women's centers' JTPA programs:

1. Number of people
2. Program enrollment by type (e.g. classroom training, OJT, etc.)
3. Placement rate
4. Average earnings at placement
5. Pre/post-JTPA wage gain
6. Hours worked per week
7. Percent who have health insurance benefit in placements
8. Occupational areas by percent and wage

Seven of the ten gave us some kind of data, and we have presented what was usable in the course of this report. None of the data sets

were complete, even aside from the fact that no SDA collected data on health insurance or any kind of benefits in job placements -- not entirely a surprise, but we thought we would try it. Few SDAs gave us separate data on the women's center participants as opposed to other women in the system. One official told us that his state didn't use the usual D.O.T. codes for occupational areas but rather Occupational Employment Statistics codes, an entirely different and thus noncomparable system. One SDA told us that their data on occupational areas referred to training rather than job placements. One SDA couldn't separate out for us data on adults vs. youth. Another had many of the items for us but said the SDA did not break out wage-at-placement figures by sex. In another, a women's center's figures and the SDA's figures on average wage at placement for the center's OJT women differed by about $2.50 an hour; each insisted its figures were correct.

The most frequent data problem we had, however, is that because neither the Employment and Training Administration in Washington nor their state governors required them to disaggregate data by sex, half of the SDAs we visited did not do so. This is not to say that data by sex CANNOT be available; indeed, it must be there since all SDAs report raw data on participants that includes female or male. The information has to be in the computer, but getting it out may involve some new programming and thus be some trouble, or perhaps some JTPA officials might prefer not to see the results.

Even more disappointing to us was the attitude of a number of SDA officials to our questions about performance data by sex. For instance, in one SDA that sent the raw data to the state for analysis and got it back aggregated for all participants (except for X percent female, Y percent male), an official told us that the subject of different outcomes for men and women had never been brought up before. Another told us that we were the first ones to ask about it. It is of course possible that these SDAs actually had the data we wanted but refused in this fashion to give it to us. We rather doubt it. They seemed quite sincere in their surprise at the question, and not particularly inclined to find it an interesting one.

The SDA that collected and reported the most complete data by sex, ironically, had the worst outcomes for women of any we saw: women earned an average of $1.14 an hour less than men and worked an average of 7 hours a week less. Moreover, this SDA was the only one to our knowledge that distributed the outcomes by sex on participants in the entire SDA as well as those in their programs to all of its training providers every month. The person responsible for the women's center program simply filed this valuable information away without studying it.

The only male/female JTPA data required by the federal government is the percent of each sex served. As a result, most states don't require more from SDAs and most SDAs don't require more from contractors. While we certainly don't argue that knowledge is

sufficient -- witness the SDA whose average wage-at-placement figure was $4.99 for women and $6.13 for men -- we do suggest that if JTPA is not aware that women are faring worse than men it is even less likely to address the problem than if it is aware.

Female vs. Male Leadership in JTPA

With limited data, it is not possible to draw solid conclusions about whether women enrolled in JTPA were better off in terms of decent jobs and wages in SDAs with female leadership than in those with male leadership. We did, however, interview JTPA staff directors, associate directors, or assistant directors in six SDAs, and women were administrators in three of them.

By and large, female JTPA administrators seemed to us to be only slightly more understanding of women's needs and the barriers to their success in the labor market than male administrators were. One of the best indicators came in response to the question of who -- men or women -- were better served by JTPA. In most cases, the men as well as the women we interviewed recognized that men tended to get a better deal from JTPA.

A woman assistant SDA director said this was because ...

some of the greatest opportunities we have are with customized training. They're primarily in male-type positions. Also, the men probably have less competition for the jobs. We have a number of women who want to go into clerical word processing. They're competing with women who have two-year degrees in word processing, and for administrative assistant positions even with women with four-year degrees. So men don't have the competition that females have. And third, women still have the higher need for the higher wage because of the cost of day care, and they get the lower wage.

A male SDA director thought that men were served better by JTPA than women because "employers hire men for the best-paid jobs." He understood very well the barriers facing women with child care needs:

It's difficult for a woman if she has a high dependency on child care, because the entry-level wages are not high. The problem is, if you have a female head of household with three children, it would cost -- if you worked out a deal -- at the very least $400 a month.

And a female SDA director said,

I would think that any family where there are two adults in it would be better off under JTPA than any single individual with dependent children trying to go to work through this system. When there's only one parent that has to do everything, the options are terrible. And in most cases, there are still fewer men who are single parents than there are women. So I'd have to answer you by saying, yes, I think women are worse off in this, because they have the children.

Going below the SDA administrator level now, the administrator of an SDA-wide OJT contract, a woman, felt that her SDA wasn't sufficiently sensitive to women's needs for child care, transportation, and medical insurance. No, she said, she had never seen studies reaching this

93

conclusion, but she assumed women trainees had these needs because she was a single parent herself and thus had first-hand knowledge. She was particularly concerned by the wages women were getting:

> Women are willing to start at the bottom and work their way up, but they have a lot to lose with no welfare and a low-paying job. A woman with children can't live on $4.50 an hour -- half of nothing is nothing to her.

On the other hand, both male and female staff members were capable of sexism. A male intake center director told us that women left JTPA better off because there was a high local demand for clerical workers. He felt that "local sentiment" was that JTPA's role was to help women "get their lives together," while it should help men "get a job like they should get." And a woman JTPA counselor blamed women for being reluctant to leave welfare for a $4.50-an-hour job:

> Counselor: I see a hesitancy to take that step [leave welfare]. It's threatening to them. It threatens their security.
> Interviewer: Emotional or financial security?
> Counselor: Both, but especially financial. I think they have a desire to do things on their own, but giving up that security of knowing that their kids are going to be fed and medically cared for is hard for some of them.
> Interviewer: But how could any parent give up that kind of security?
> Counselor: By wanting to get somewhere. I think that many people nowadays [she was in her late 30's!] are not willing to sacrifice what it takes to get beyond the subsistence level. I think that once they realize it's not going to happen real fast and it's going to take a lot of sacrifice on their part, they get scared and they're not willing to work hard for it.

94

She thought women ought to be home with their children:

> Sometimes you just put off your own career if you feel
> that it's important to be home with your children. I
> stayed home until my youngest was four, when I started
> working part time, just by choice, really. Lately I've
> worked full time, again by choice. I enjoy working.
> It's nice to have a choice. I'm fortunate in that
> respect.

For the most part, though, the difference between the male and female JTPA staff, to the extent there was one, seemed to us to be a somewhat greater sensitivity, a greater immediacy of identification, on the part of the female staff to barriers women face and needs they have. A woman SDA director thought that having women in leadership roles in JTPA was very important, not because men deliberately discriminate but because they have not been responsible for the day-to-day raising of children and thus are not acutely aware of how child care, health insurance, and the like shape women's experience before, during, and after JTPA.

We think she framed the issue in this way because taking the lead to improve women's lot in JTPA is now based on personal commitment, not an official policy in the system. The only SDA we visited to put such a personal commitment into action -- where salary bonuses were paid to JTPA staff members who managed to get women into higher-paying jobs (see Chapter 2) -- was run by two women. While there is nothing to prevent men administering SDAs from doing the same, we suspect that as long as serving women adequately is a matter of personal preference rather than

policy, female leadership in JTPA will be correspondingly important.

- - FIVE - -

APPLYING FOR JTPA CONTRACTS FOR WOMEN

IN THIS CHAPTER

Getting and Staying Funded
Why Women's Centers Choose Not to Have JTPA Funding

Getting and Staying Funded

From the point of view of the SDAs that we visited, funding women's centers was clearly a desirable thing to do.

In an SDA that had an excellent relationship with the women's center, which in turn had an excellent reputation for working with women who had multiple barriers to employment, a deputy director admitted that the hardest-to-place women were often sent to the center: "Here are 30 of our worst clients; see what you can do with them." The center often did fine with them, due in part to the supportive environment created for these clients and the commitment to building their self esteem.

97

Staff in several SDAs also mentioned the common sense for JTPA, which is required to serve a good proportion of women, in relying on women's organizations with expertise in reaching and serving them. We also talked with women's center staff members who spoke with high praise of their JTPA program officers as caring people, committed to women's welfare and willing to help them work out the best possible contractual terms.

Several women's centers, however, had reservations. One staff member told us that while her SDA respected the center because of its excellent performance record with contracts, nevertheless ...

> They are paternal. They have a fantasy attachment to us.
> Because of us, they think they help women. Of course, we
> take advantage of this.

One women's center staff member bluntly charged that contracting to a women's center let other JTPA training providers in town off the hook while allowing the SDA to keep its female numbers up:

> I remember seeing a report last year on a breakdown of
> the women and men that were served by all the programs.
> I noticed that our program had a lot more women than any
> other program, but the others have a responsiblity for
> serving women as well.

Support for this charge cropped up in another SDA and the women's center it contracted with, both of which served women poorly. The center's three-part contract required it to: 1) provide outreach to 100

women per year -- which it succeeded in doing by eliminating a focus on NTO and concentrating on easier sex-traditional recruitment, 2) supply 35 incidents of support services to women and men throughout the SDA, which included providing needs-based payments (for glasses, for example, or work boots) out of a budget of $1,000 per year -- the center returned $729 of this at the end of the year as "not needed", and 3) provide half a day of inservice training once a year to local JTPA contractors if they cared to come -- but the center chose not to devote any of the sessions to issues of exclusive importance to women. The director of this center was the same one who recommended to the SDA that child care not be paid because women allegedly did not need it.

Nevertheless, several people in this town told us that because the SDA had a contract with the women's center, they believed that women's needs were being met. The director of the local intake center, for example, after speculating that child care and transportation problems probably kept women from enrolling, figured that he had to be wrong because the women's center was providing support services to "everyone who needed them." Of course, the center wasn't. The president of a business college, an important JTPA contractor in town, assured us that JTPA works very well for women because, he said, the women's center "is there to look out for their interests." Needless to say, it was not easy for the interviewer to maintain a neutral expression.

Most women's centers mentioned the importance of obtaining and grooming political contacts, specifically those occurring at meetings of the Private Industry Council, or PIC (the decision-making body in each SDA). One person called attendance at PIC meetings critical for being "plugged into the process." Someone at another center mentioned going to every single PIC meeting to find out what monies are available, who else is getting funded, and what the current priorities are. She explained further benefits of attendance:

> It shows we're accountable, but it also shows we know what they're doing. By being there each time we get the image of having more political power than we actually have -- they think we are "The Women" and we have all the women in town as our allies.

Many centers agreed that it was especially important to attend meetings to learn about the areas the PIC was having trouble meeting goals in. An SDA that was not meeting its youth goals, for example, would theoretically be ripe for a proposal from a women's center for serving teenage girls.

Several centers emphasized that while attending PIC meetings was necessary, it was not sufficient. They also spent a significant amount of time making friends with PIC members. One center made it a policy to have lunch with each PIC member, with the initial lunch set up by a friendly "link" who calls the "target" to set up the lunch. Another technique of theirs was to invite PIC members to their headquarters,

where job training was held: "It is an educational experience for PIC members to see these women they are funneling money to."

While lobbying the PIC members is not a substitute for solid performance in JTPA contracts, it can certainly help resolve difficulties, sometimes dramatically. One center told us about the time a couple of years ago when, in negotiation with SDA staff, they were obliged to turn down a $350,000 contract because they could not make the shift to performance-based contracting in time. The center called an influential PIC member, who called the SDA director, who got the contract altered so that the center could accept it.

Seven of the fifteen women's centers we visited had advisory board members who were also members of their local PICs or, in a couple of cases, high SDA administrators. We wish we could report that this is the secret of JTPA success, but it is not. Three centers felt that having a JTPA-connected board members was quite valuable for inside information, three were disappointed by the lack of support from their board members, and one felt that it made no difference at all. One women's center staff member expressed the ambiguity inherent in the situation when she said:

> Having feminist women in the JTPA system has helped us tremendously, but when we go in for contract negotiations it can get tricky. They switch hats between feminism and JTPA goals.

Contacts with SDA staff are different but equally important, and in general we found mutually respectful and supportive relations between women's centers and SDA program officers. One center emphasizes discussing the features of new proposals informally with staff before submitting them, to make sure JTPA is "invested" in the project. As a result, they said, most of the contract negotiation is in reality carried out before the proposal is formally submitted:

> If you just shoot a proposal over there, they are not invested in you. You have to call ahead of time, let them feel that some of the project is theirs.

Another center makes sure that SDA staff remain invested in the programs they've worked on together by inviting them to attend classes, graduations, and other events.

As an example of the fruits of good center/SDA relations, we were told about the time an SDA issued a Request for Proposals that in the center's opinion was too confused to respond to. The director canvassed other community-based organizations in town that were regular JTPA contractors and learned that they agreed. Jointly the group approached the SDA, with the result that the necessary changes in the RFP were made. Another example is calling SDA staff to request exceptions to rules for certain individuals, which are sometimes granted; still another is moral support from the program officer to the director of a new program whose success is uncertain ("we hold their hand").

A JTPA-experienced women's center director, reflecting on how to get a JTPA contract, said: "Influence, contacts, and administrative skills. Not merit." The SDA people we spoke with, however, were quite clear that a prime component of the decision to fund a center was demonstrated past success. It could well be, however, that the center director and the SDA people had different definitions of "merit".

Why Women's Centers Choose Not to Have JTPA Funding

We visited five women's centers that did not have JTPA contracts. A few had submitted proposals that did not win for a variety of reasons which formed no pattern. They all, however, knew very well why they preferred not to apply now. These were their reasons:

o There was another women's group in town that had JTPA contracts, and the center saw no point in competing with it.

o The proposal requirements are lengthy and complicated, hard for a small women's center staff to accomplish.

o A small women's center staff also cannot spare the time to do all the politicking necessary to get funded.

o "Innovative programming is not available through JTPA," said one

staff member. "There is no point in establishing yet another clerical program."

o A center wanted to do NTO programming, but high costs would not be approved by the SDA and the constraints of the performance standards were too severe to do NTO successfully.

o One center's target population was displaced homemakers, primarily white and middle-class, while the SDA's emphasis was on minorities. The center decided it did not want to change its focus.

o Another center that served displaced homemakers felt that funding prospects through the ten percent window were too uncertain. (The ten percent window is an exception the law allows for people whose income is higher than the guidelines permit but who have serious barriers to participation in the work force nevertheless.)

o Paperwork. We heard many, many complaints about the amount of paperwork involved in submitting a proposal and especially in administering a JTPA project. Our impression was that this was an especially big issue with smaller centers that were not administratively sophisticated.

o There were concerns that JTPA eligibility guidelines would pose unacceptable limits to a center's ability to serve a wide range of

clients. Several pointed out the contrast with Perkins vocational education funds, which are not nearly so restrictive.

o According to the director of a college-based women's center, applying for JTPA money can be risky. With JTPA funding the center, the college would phase out its internal support for the center as no longer needed. If the JTPA money were then to stop, the center would have to close. Moreover, few women's centers are in a strong enough political position in their colleges to force administrators to agree to a resumption of internal funding if necessary.

o One center director thought that contracts go to the PIC members' organizations.

o One center reported great difficulty getting information about JTPA out of the local SDA, getting her questions answered, and finding out who made decisions. She had tried and failed to have her center put on the SDA mailing list. In fact, as we learned when interviewing an SDA official in that city, there was no mailing list: we were asked to believe that RFPs (requests for proposals) were announced in ads on TV and radio and in newspapers, exclusively.

o In a meeting of nine directors of battered-women's shelters at one site we visited, the group agreed that job training was critical for this population. As one woman said,

> Probably the biggest reason women return to a violent
> home situation from our shelter is the lack of
> employment. A long-term solution for battered women has
> to include job training.

Nevertheless, none of their shelters had applied for JTPA funding.
They gave the following reasons:

- The crisis orientation of battered women's shelters makes long-
 term planning and preparation difficult.

- One shelter had tried to apply. Having questions about filling
 out some of the forms, this person called the SDA repeatedly but
 received no help.

- Applying would mean competing with a local community college.
 This would not be a politic move.

- There are no facilities for job training at the shelter.

- Job training would be a distraction from their central mission of
 domestic violence.

This group had managed a few years earlier to get the local SDA to
recognized battered women as appropriate for the "ten percent window."
Without the ten percent window for battered women, one shelter director
told us, battered women are often in a Catch-22 situation:

There is no legal separation in this state -- either you're married here, or your're divorced. And this is a community property state. So a wife legally owns half of what her husband has, but if she can't get at it, if she's too afraid of him to go back for it, then she's homeless and destitute but the rules say she's over the income guidelines. In this way the rules force her to return to the man who's beating her.

None of the shelter directors had contracts, so none knew for certain that the 10 percent window was in fact being used for battered women. They had heard, however, that the SDA tended to use it as a reserve fund for individuals whom audits later revealed to be ineligible according to the income guidelines.

The director of the community college women's center reflected on the impact of the JTPA pre-employment contract her center had had the previous year as she explained to us why she would not apply again. We quote her extensively because we think she addresses extremely well the sense of frustration with JTPA that many women's centers expressed, both those that experienced JTPA contracts first-hand, and those who only heard about it from others.

JTPA affects women's centers most severely by making them start to cream. They start to think whether this woman will be a placement. They think of the client in terms of dollars and cents: can I afford to take this client? It makes them think in terms of outcome rather than the presenting problem of the client. They also have to ignore a lot of problems, the ones the JTPA program can't address, so what's happening is that only part of a client is being served. You can only give them what you're funded to give them, and you HOPE some other

agency will help them with the rest, which is sort of a joke.

For example, if you go to a JTPA-funded program you're not going to get any counseling. The client might be in a battering situation or just desperately need a couple of hours of personal counseling, but you're not funded to do it. Or you need a minority person really badly to fill your quota, so you pass by two non-minority women who are low-income and struggling. You fill your quotas that way. And the ones who are marginal and you turn them away -- where do they go? The kind of humanity and compassion and sisterliness and the belief in the good of each person that we had in women's centers, a lot of that is lost by the philosophy of the JTPA funding source.

And then pretty soon you start to hire staff that reflects that personality. If you've got someone who's a soft-touch social worker, who wants to help everyone who walks in the front door, pretty soon you're going to say to yourself, "The next time I hire someone it will be someone who's a little more distant and can turn a person away without feeling so lousy." That's a big change from what we're about, which is NOT turning people away.

Wanting money to keep your agency alive is understandable, but maybe simple survival isn't what we should be doing. We need to look at how we're surviving. What does this do to the soul of our movement? Maybe it changes how we treat women, and if that's true maybe we all need to fail. Lots of women's centers have tried to be like the boys and take the money, but sometimes it doesn't work. We've sold our very soul for this. We have to rethink the whole thing. We have to be able to say, "I don't like what I have to do to get your money."

- - SIX - -

CONCLUSIONS AND RECOMMENDATIONS

IN THIS CHAPTER

The Women JTPA Serves and the Women It Doesn't
How JTPA Fails Women
Recommendations

The Women JTPA Serves and the Women It Doesn't

Performance standards drive the JTPA system, from the legislation through the Employment and Training Administration in the Department of Labor down through the state level and on to the Service Delivery Area offices and down to the service providers under contract to JTPA, and finally they wind up at the level of the low-income women without job skills who need training and help to make it in the labor market. At each level the performance standards, as currently defined and understood, dictate choices. We heard the same refrain over and over again: "the performance standards made me do it."

> JTPA counselor: Our program is dependent on funding. We have to get money back in order to provide services for people. So a woman has a responsibility to us when she is registered in our program to finish training. If she finishes training, we get money. So we look at this kind of person and say, "Are there too many obstacles out there in terms of her children, the ages they are, and

the experience that we've had in this area before, is she a good risk for us?" Here's an example. We had one woman who came in and wanted to go into training. I think she had four children. Two of the children had been sexually abused. She was in therapy and the children were in therapy. We just didn't feel that she was capable, emotionally or physically, to take on something else. We talked to her and we encouraged her to come back and apply after the therapy was finished, or after she felt more complete as a person.

The performance standards can also, as this quote demonstrates, make hypocrites out of people who work in the system -- even out of this counselor, who we saw was a sensitive and caring person. The woman she spoke of had wanted job training, and the counselor could not be sure that the woman would not benefit from it. Nevertheless, the woman was denied access to JTPA supposedly for her own good, but in reality because the counselor's intake center refused to put its payments at risk. Notice the same theme in this statement by a JTPA counselor in another state, when we asked what the counselor's intake agency did when a woman calculated that she wouldn't be able to afford child care on the type of job JTPA was proposing to her:

Our procedure in that case is not to enroll that client into training. It's new to us. At first it was a little upsetting because we'd been so liberal about child care and I thought, "Oh heavens, we're going to be a barrier." Sure, they got the training, and education is something they'll always have, something no one can take away from them, but they were facing not really being able to use it, at least at this particular time in their lives, for lack of child care assistance. So I think this is a much more realistic approach, and we're really doing the client a favor.

110

While the women's center staff members we interviewed turned women down just as often as JTPA staff and for the identical performance-standard reasons, at least they were not under any illusions about how it was good for the women. The women's center staff members knew the fault lay in the program, not in the women.

> Interviewer: Do you ever find yourself discouraging some women with a lot of needs from signing up for your program because they might hurt your numbers?
> Staff member: Yes, that is very true. If you have someone who comes in with a drug abuse problem your success rate is going to be less. If she has five or six children, the jobs that we have are not going to be enough to support her, and if we place her she would have to quit her job because she can't make ends meet on it.

Creaming -- the selection of people with built-in advantages that make success likely -- was a frequent and open topic of discussion. A JTPA counselor said it worked like this:

> Many times the participant will say, "I don't have to worry. My parents live two doors away and they're going to move in and they're just so supportive and will help with my kids, and I don't have a thing to worry about." We take all that into consideration. We accept people who do have problems, of course, but they feel they can overcome some of the obstacles.

Notice, by implication, whose responsibility it is to overcome the obstacles. Everyone spoke of creaming. A JTPA intake counselor said:

> I'm at the front of the assembly line here. There's a lot of creaming -- it's all a numbers game. It seems to

me that we were not set up that way, but we have to turn
the clients into cream to win the numbers game.

At a PIC meeting called to discuss the SDA's failure to meet its

performance-standard obligations, one PIC member stated:

Let's be honest. To meet the performance standards, we
have to cream the population.

We should be honest, too. In a severely underfunded national

program that serves less than five percent of eligible persons, the

performance standards become the triage mechanism for selecting the few

who gain access to JTPA services. Individuals permitted to enter the

program are those who will help SDAs and program operators avoid

punishment (defunding) and earn rewards (incentive awards, refunding).

As one women's center staff member ruefully commented as she compared

JTPA with the old CETA program,

We used to meet someone where she was. Now she has to
meet us where we are.

Oddly enough, women on welfare are in a privileged position insofar

as JTPA goes: they are the only ones whose survival needs are assured

throughout training. Women on welfare can afford to be in training for

six months or more, should they be lucky enough to have such a "long"

program. Women on welfare receive Medicaid automatically, and do not

feel they have to rush right into a job in order to get health insurance

coverage. Welfare departments often pick up the cost of child care. A

woman on welfare is a safer bet for JTPA, since she has institutional resources to fall back on. It is not surprising that although the performance standard for placing welfare clients has increased almost by half since JTPA's beginning in 1983, far more than any other performance standard, it is widely met by SDAs.

We realize how powerful a force the performance standards are. Indeed, we have detailed their power throughout this book. Nevertheless, we could not help but wonder at the expression of all this helplessness and inability to function as anything other than a cog in a wheel. For example, an official of one SDA boasted of exceeding his local adult performance standards in the last Program Year as follows:

	Standard	Actual
Adult entered employment rate	58 percent	69 percent
Cost per entered employment	$4,891	$1,996
Average wage at placement	$4.99	$5.06
Welfare entered employment rate	45 percent	59 percent

Surely, it seems to us, an SDA that exceeds its performance standards by so much could afford to spend more money to take in clients whose needs cost more than usual, could afford to take a few more placement chances. Or is it possible that the SDA chose instead the three quarters of a million dollars in incentive award money it did in fact receive for exceeding the performance standards so greatly? Similarly, why can't the SDAs we visited, especially those that complained so bitterly about the high cost of child care, apply for a waiver of the 15 percent limit

113

on support services to enable them to accept more women with high child-care expenses rather than favor women whose mothers take care of their kids for free? Their incentive awards surely make up for the loss of money allocated to training.

We recognize that it is sticky for women's centers with JTPA contracts to protest JTPA policies, but it is possible, especially through the National Association of Women's Centers or other coalitions. Women's centers, especially those whose SDAs are exceeding the performance standards, need to do more to bring political and publicity pressure to bear on JTPA officials whose success is achieved at the expense of low-income women who are entitled to but are denied decent job training. Women's centers told us repeatedly that JTPA would refuse to fund the high cost-per-placement proposals that adequate service of women's needs require, but how many women's centers organize other groups in town that serve high-need populations to protest this policy? How many centers devote more effort to lobbying their PICs and/or their governors for more realistic performance standards on contracts serving women rather than live under protest with the tight standards in the contracts they have?

How JTPA Fails Women

The JTPA legislation speaks of "preparing youth and unskilled adults for entry into the labor force," increasing the "employment and earnings of participants," and achieving "reductions in welfare dependency." These phrases are deceptively simple. Surely the framers of the legislation did not have in mind that youth and unskilled adults should enter the labor force and then leave it again after a few days, or that it is a triumph to raise participants' earnings a nickel an hour over the little they earned before.

It may be more helpful to think about what these phrases mean in plain English. We therefore suggest that **the point of JTPA should be to enable poor and unskilled people to get jobs and keep them, and the point of doing that is to support themselves and their families.** In this light, the low-wage jobs of JTPA take on new meaning.

The wage-at-placement performance standard for Program Years 1988 and 1989 is $4.95 an hour. Officials at the Employment and Training Administration in Washington freely admit that this standard is far and away the hardest one for SDAs to meet, and in fact many SDAs do not meet it. The ETA does not require SDAs to compute wage at placement separately by sex and so reliable national figures are not known, but at five of the SDAs we visited (providing data on a total of about 8,000 women and 7,000 men), women earned an average of $4.72 upon placement

115

into jobs, which was 52 cents an hour less than men earned on the average. Moreover, women had a lower placement rate in these SDAs: 52 percent for women and 61 percent for men. As we saw in Chapter 2, the occupational segregation in the system -- the lack of nontraditional occupations for women -- is at least in large part responsible for the fact that women's wages tend to be lower than men's. One intake center director was not being entirely facetious when she told us that she considers any job that pays women a living wage to be a nontraditional job.

We asked many people in our interviews how much a woman would need to earn to survive in their areas. Responses were surprisingly uniform:

> You'd need at least $7.50 an hour to get off welfare.

> You need about $7 an hour around here to equal welfare, with food stamps and all that.

> You have to move into $7 an hour jobs to survive.

> I hear that women need at least $8 per hour to support children.

> Around here you need a minimum of $7 an hour to survive, assuming you have to pay day care for at least one kid, to pay the rent and put food on the table, no extras.

If anything, these people may have underestimated. The Census Bureau reports that in Earning Year 1987, the poverty line for a two-person family, such as a single parent and her child, is $7,399. The Child Care Action Campaign, a national organization, estimates that the

cost of child care in a day care center in seven major American cities averages out to about $350 per per child per month (although the figure is based on November 1985 data so the cost is doubtless higher now). If one assumes that a woman is earning a wage for 35 hours per week and 52 weeks per year, she would have to earn $6.37 per hour to pay child-care costs for her son or daughter and live right on the poverty line. To pay child-care costs for two children and live at the poverty line for a three-person family ($9,056), she would have to earn $9.59 an hour.

If she earns less than these amounts, either she lives below the poverty line -- in which case she has to quit her job and go on welfare to assure food and shelter to her family, or else she cannot pay her child care bills -- in which case she must quit her job to take care of her children, and then must go on welfare to assure food and shelter to her family. And if she earns $6.59 an hour with one child or $9.37 an hour with two, but her job does not provide health insurance, a relatively minor medical expense may force her to quit her job in favor of welfare with its health insurance coverage.

It will not do to object that JTPA wages are low because they are only intended to be entry level and that participants are responsible thereafter for good job performance and further training leading to better salaries. How does a woman last until then? The supermarket will not give her a discount while she is earning an entry-level salary, and neither will her landlord. An entry-level salary that does not

117

permit subsistence is simply nonsense language. "Increased earnings" as a JTPA goal at best is meaningless. The goal of JTPA, again in plain English, cannot be "more" money for trainees: "more" than "not enough" may still be not enough. Imagine a person who normally needs 2,000 calories a day to survive and is starving on food that provides only 500 calories a day: should we be praised for increasing the food allowance to 1,000 calories a day?

It also will not do to point out that women do, in fact, get jobs after JTPA. First, we do not know how long women last in these jobs. It is at least possible that there is a serious dropout problem when women find that they cannot live on their low-wage jobs. The new followup performance standards will at least tell us how many JTPA participants are working three months after leaving the system, which is not very long but is better than the ignorance we have had until now.

Second, our own interviews indicate that the women who are working are those who have special help with child care, or they are making taking risks with their children's safety they should not be required to take. Every one of the nine JTPA women we interviewed who were working was the sole support of her family, and each one had children. Four of the nine had relatives taking care of their children for free (an unemployed husband, a disabled husband, a disabled mother, and a sister), and the children of three others took care of themselves -- in one case, a 12-year-old was taking care of a 3-year-old. The eighth

woman was working part time and welfare paid her child care. The ninth woman was the only one to pay for child care, and not coincidentally she was the only one to earn as much as $8 an hour -- as a machinist.

We seriously question the sense of a program that prepares women to earn so little that without unusual advantages and resources -- free child care, free rent, or someone to pay their bills -- most of them cannot support their families.

It should be clear by now that the central reality for women in JTPA is that most are heads of household. Twenty-seven of the 31 women we interviewed were the sole support of their families; seven were supporting disabled or unemployed husbands as well as children. The central reality is children. The central reality is child care. A single person and a mother who is the sole support of her children are not equal. It is not enough for women to earn $4.95 an hour, the national wage-at-placement performance standard. It is not enough for women to earn an average of $5.24, as men do now in the SDAs we visited. It is not even enough for women to earn an average of $6.13, the highest men's average in any of our SDAs. Women need to support families, so they need to earn more money than this.

If women are to join the labor market and stay in it, we cannot have it both ways. Either JTPA must see to it that women who are single parents prepare for jobs where they can earn enough money to pay for

child care -- meaning entry-level wages of more than $6.37 an hour with one child and more than $9.59 an hour with two, or else we must subsidize their child care costs until their wages are high enough to live on, however long that takes. Increasing child support collection from absent fathers would help, and decreasing occupational segregation would help enormously. Traditionally male jobs tend to pay considerably better and have higher career ladders than traditionally female jobs such as clerical, clerical, and clerical. We cannot continue to blame women for staying on welfare if we give them no alternative, and we cannot continue to provide JTPA services only to those women who have the advantage of financial support from welfare or elsewhere. Most of all, we cannot continue treating JTPA clients as if they -- and their needs -- were identical.

The limitation on expenditures for support services to 15 percent of an SDA's allocation, a limitation that superificially falls evenly on men and women, in reality hurts women more. Because women, more often than men, are responsible for children, inadequate support services means less money not just for the trainee but also for child care, less money for health coverage of children's medical needs, less money for emergency rent payments to keep children from being evicted. It means that transportation allowances for trainees alone ignore the reality that many single parents need to transport children to and from child care. Inadequate support services mean no counseling or not enough counseling for displaced homemakers, who have many desperate needs to be

120

met before they can function well in the job market. And 15 percent's worth of support services would be a luxury in many SDAs, where the goal is apparently to spend as little as possible.

Finally, it will not do for JTPA to put its head in the sand as it has been doing. What JTPA doesn't know may not hurt officials of the system in the short run, but it surely hurts women in the program. The data collection problems we have discussed are not trivial technical issues. If the only information on women widely required is the percentage of female participants served and if no outcome information -- hours worked per week, average wage at placement, placement by occupational area, and others -- is available by sex, then the system's failure to serve women adequately remains officially invisible except when reports such as this one are published. We stress "officially": the women poorly served in JTPA, of course, and those who are excluded from it, know that their job-training needs are not being met. Invisible problems, as we all know, are not addressed and corrected.

For example, we do not know whether minority women fare even more poorly under JTPA than white women. We heard some stories, one about a racist instructor, another about a racist employer, another about discriminatory job interviews. We had asked for data by sex, not by race/ethnic group, but it is quite possible that the stories of racism we heard from some of the seven Black and Hispanic women we interviewed are part of a pattern in JTPA. Without data disaggregated by race, this

might be another invisible problem.

We suggest that ignorance of what is happening to women in JTPA, caused by insufficient data collection requirements, also hurts the American taxpayer. The Fiscal Year 1988 JTPA allocation for Title IIA, the major source of job training for adults, is $1.8 billion. Nearly two billion dollars, while not nearly enough in view of the numbers of low-income adults needing job training, is still a large amount of money. If women are poorly served by JTPA, are we getting our money's worth?

We propose a frank, open, and national commitment to improving disadvantaged women's jobs and wages through JTPA. This is not sex discrimination in favor of women but rather a matter of justice. For those who prefer a different reason, it is also smart economics. Millions of JTPA-eligible women are raising more millions of children in poverty with no help from the children's fathers. Preparing these women for good jobs at good wages today is expensive, but paying the costs associated with a childhood of poverty for their children tomorrow -- poor health, crime, joblessness, a new cycle of deprived children -- is astronomical. Even schoolchildren can figure out the arithmetic of that one.

Recommendations

We do not question the value of performance standards in a publicly funded job training program. It is reasonable for the public to be assured that in exchange for our tax money the program will in fact train and place a substantial number of low-income people in jobs that pay enough to live on and that have a future.

The question is not whether JTPA should have performance standards, but what kind. We hope this book has amply demonstrated that JTPA performance standards, as now constituted, have done a great deal of harm to women. The standards for placement rate and cost per placement have operated virtually to require occupational segregation and keep women out of nontraditional job training, have made training programs as short as possible and therefore given trainees fewer job skills, and have limited support services below what many women need.

While the JTPA performance standards have harmed women, we believe that women are an unintended casualty of the performance-standard structure. The inflexibility of the standards in practice prevents allowances from being made for any people with special job-training needs, not only women. The incentive-award premium placed on exceeding the standards means that all people with advantages are creamed, not only women. Although our contention has been that women suffer most from these shortcomings because of their child-raising responsibilities,

men suffer from them as well. In this light, we have five major recommendations and a number of additional ones for JTPA and women's centers. As each recommendation would, if fully spelled out, require a separate book for itself, we are limiting ourselves to statements of ends rather than means.

Major Recommendations

1. **We recommend that incentive funds no longer be awarded for exceeding performance standards.** More than any other single change, we believe that relieving the pressure on SDAs and program operators to cream would create the most significant improvement in terms of service to women in JTPA. It is counterproductive and it is wrong to reward an SDA for spending less than $2,000 per trainee -- which can only buy short, cheap training that leaves her nearly as badly off as before -- when $5,000 is available for training that would prepare her for a job that pays a living wage. Far better would be to attach incentive awards to success in training and placing people according to their labor-market participation barriers -- which, let us recall, is the point of the program. One such barrier should surely be responsibility for dependents.

2. **We recommend that the stranglehold of inflexible performance standards, in which no client risk is too small to be avoided if at all possible, must be broken.** JTPA clients are not interchangeable cogs,

124

and their needs are not the same. The national guidelines should be
changed at the state level or elsewhere from goals for everyone, as they
are now widely taken to be, to ceilings. A placement rate of 68
percent, for example, would apply only to persons with no special
problems that might hinder placement. The adjustment for nontraditional
placements, for example, might be 58 percent. The adjustment for
placing displaced homemakers might be 50 percent. The adjustment for
placing battered women might be 45 percent. In exchange for more
reasonable goals, we would have surer placements and more self-
sufficient women.

**3. We recommend that the new "followup employment rate" performance
standard be strengthened.** It should be changed from client status at 13
weeks after program completion to client status at one year after
program completion, and this standard should be the primary one by which
all state and local recipients of JTPA funds be judged. With
unmistakeable emphasis on longevity in the workforce as measured by
employment after a year rather than only three months, JTPA units from
states on down will have more incentive to provide the support services
women need to get and keep jobs, and more incentive to insist on
training for higher-wage jobs -- including nontraditional occupations --
that women can support their families on.

**4. We recommend institutionalizing society's interest in women's
employment by assuring them affordable child care and health insurance.**

In the absence of a publicly-supported child care program in this country, **child care** should be fully provided for all women enrolled in JTPA who need it, meaning elimininating the problems described in Chapter 3, and should be provided into the employment period until they can afford to pay it themselves from their paychecks. We specifically urge that the cutoff date for the benefit be based on a woman's ability to pay child care on her own rather than an arbitrary number of months: there is no advantage if a woman quits her low-paying job and goes on welfare later rather than sooner because she cannot afford unsubsidized child care. Since the lack of **health insurance** in JTPA forces women to shorten training time and enter the job market before they have adequate skills -- a short-term gain for a long-term loss -- we recommend that health insurance be provided to women throughout their JTPA enrollment if needed. On a broader scale, health insurance, the means to the end of health care, should be provided to all Americans at all times regardless of their employment status as a matter of human decency as well as national economic self-interest.

5. **We recommend energetic and committed leadership to improve women's lot in JTPA.** In a deliberately decentralized JTPA system, the federal officials, state officials, local officials, and contractors all freely blame each other for failings and frustrations. There is justification for this: they all contribute to the inadequacies in service to women that have been described in this book. There is no justification whatsoever that each level fails to blame itself as well. The

Employment and Training Administration is able right now with tools at its disposal to force state governors to take action that will benefit women. State governors are able right now with tools at their disposal to force SDAs to take action that will benefit women. SDAs are able right now with tools at their disposal to assist women's centers in their efforts to benefit women. It is time for all these components to stop hiding behind each other and take the lead -- which includes soliciting and acting upon honest feedback from lower levels in the system -- in making it possible for women's real job training needs to be met. Promoting more women to the level of SDA director is not an automatic solution, but it will help.

Additional Recommendations for JTPA

Funding. Training low-income women for jobs that last is inevitably expensive, and most of those who need this help are not being served. Considerably more money needs to be authorized for JTPA.

Contracting with women's centers. SDAs should be encouraged to contract with women's centers as community-based organizations that understand women's needs and have links to women in the community.

Governors, SDA staff and PIC members. They need to be enlightened about women's needs and the system's shortcomings in meeting them. Even within current constraints, including existing performance standards,

more can be done to assist women in getting jobs they can live on. A combination of training, programmatic requirements, official communications, incentives and disincentives, and other means can be employed to convince these officials that improving service to women is essential.

Reforming the payment system. Partial payments to service providers should be scheduled not by benchmark dates (client enrollment, completion, etc.), since these are often far apart and create serious cash flow problems for women's centers. Payments should instead by scheduled on a regular calendar basis.

Limit on short-term training. SDAs should be required to prove that training lasting less than six months will result in placing a woman in a job paying a wage she can live on. The presumption should be that short-term training programs cannot provide her with sufficient job skills for success in the labor market unless proven otherwise.

Nontraditional occupations. Nontraditional occupations for women must be explicitly encouraged, possibly by monetary reward or other incentive to SDAs and service providers for success.

Analyzing exclusions. SDAs should be required to document reasons for not enrolling people into the system, to ensure that eligible women are not excluded because of child-care costs either in training or in

128

expected jobs.

Raise women's wages. SDAs should adopt the Fort Wayne model and pay salary bonuses to staff members responsible for raising the wage at placement for women.

Support services. Funds for support services should be separated from the cost-per-placement calculation, the effect of which would be to remove the incentive to keep support costs as low as possible. Reserving 15 percent of an SDA's allocation for support services should be considered a minimum, not a maximum: waivers of the 15 percent limit on support costs should bring an SDA additional funds so that it is no longer obligated to reduce training or administration funds. The waiver application process should be streamlined and encouraged. SDAs should be required to return any support funds left unspent rather than spend them on training, which ought to result in the funds being fully spent as intended.

Career exploration. SDAs should be required to provide at least two days of intensive and comprehensive career exploration services to all JTPA clients when they are accepted into the program. Classes and counseling on occupational options with an emphasis on well-paying nontraditional jobs are needed to enlarge women's information base and prevent the automatic assumption and self-fulfilling prophecy of sex-stereotyped career choices.

Intake centers. No intake center should be permitted to have a monopoly on recruiting women for programs. Service providers in the system need to do their own recruiting to augment or substitute for the recruitment of the intake centers. Every intake center should be required to have a safe and well supplied play area for children of applicants.

Data collection. Data must be required for all program outcomes by sex, race/ethnic group, age, and handicap. Data should be collected on job benefits, particularly health insurance and pensions. The data must be standardized nationwide for comparability. It should be distributed widely, including to service providers, and should be in a form that nonspecialist service providers can understand if they are to profit from it.

Additional Recommendations for Women's Centers

Training for women's centers. Women's centers need to receive training and ongoing technical assistance in obtaining and administering JTPA funds. The training should be realistic, including attention to the importance of effective politicking in their communities, and how to work with SDA staffs to achieve contract terms most favorable to women.

Economics and employment. While women's centers play an important role in helping women deal with the social and emotional aspects of

major life changes, they need to pay more attention to women's economic and employment needs. Career counseling services need to be improved, especially in pre-employment programs. Staff members must help women make realistic employment choices in view of their economic needs as well as their interests and employment history. Women's centers have to take the lead in emphasizing the importance of nontraditional occupations to women's economic self-sufficiency.

Skill training. Women's centers need to move beyond pre-employment programs into skill training: women's needs for woman-focused support continue into training. For facilities and equipment, we especially recommend that women's centers forge linkages with sources of job training such as vocational/technical schools. Such collaboration between schools and women's centers can only benefit women trainees.

Multiple funding. Even a reformed JTPA will have relatively strict eligibility limits. Women's centers need to be aggressive in securing multiple funding sources (JTPA, Perkins, local government, corporate and charitable foundations, income-generating projects, others) so that ALL women who want and need job training assistance can be served.

Advocating for women. The National Association of Women's Centers should take the lead in lobbying and serving as a resource for the Employment and Training Administration. Individual women's centers concerned with women's employment need to take the same role at the

state government level. Local centers should also provide more education to SDA officials about women's needs for adequate support services and decent pay.

Data from Five Service Delivery Areas

Annual SDA-wide data July 1986 to June 1987 was provided by five Service Delivery Areas on a total of 7,897 women and 7,015 men, or 14,912 people. Women were 53 percent of this sample, precisely corresponding to their proportion in JTPA nationally.

Program types

Women are underrepresented in OJT in all sites.

Women	13 percent
Men	19 percent

Women are overrepresented in occupational classroom training in all sites.

Women	42 percent
Men	24 percent

Women are underrepresented in pre-employment in all sites. Given the confusion about the meaning of "pre-employment," the high figure for men may indicate that more men are in Job Search than women.

Women	18 percent
Men	33 percent

Placement rate

It is lower for women in all sites:

 Women 52% placed
 Men 61% placed.

It is higher for women's center women than for men in two of the three sites for which we have data.

Average earnings

Lower for women in all sites:

 Women $4.72 per hour
 Men $5.24 per hour
 Diff. 52 cents per hour

For those who worked before coming to JTPA, women's post-JTPA hourly wage was lower than men's pre-JTPA wage in all sites:

 Women $4.33 --> $4.78 = gain of 45 cents
 Men $5.31 --> $5.50 = gain of 19 cents

Hours worked per week

Women worked fewer hours than men in 4 out of 5 sites:

 Women 34 hours per week
 Men 36 hours per week

Occupational distributions and wages

3-digit DOT code area	Women		Men	
	%	$	%	$
Professional, technical, and managerial	10 %	$ 5.16	8 %	$ 6.90
Clerical and sales	43 %	$ 4.68	11 %	$ 5.26
Service	26 %	$ 4.04	19 %	$ 4.04
Agriculture, forestry, and fishing	1 %	$ 3.81	3 %	$ 4.13
Processing (industry)	2 %	$ 5.66	5 %	$ 5.46
Machine trades	6 %	$ 5.02	21 %	$ 5.67
Benchwork (assembly)	8 %	$ 4.57	8 %	$ 5.14
Construction	2 %	$ 5.63	14 %	$ 6.00
Miscellaneous occupations	3 %	$ 4.36	11 %	$ 5.03

JTPA Women Interviewed in This Study

Number: 31 women.

Age

Range was 23 to 61, with the average age 39.

Race/Ethnic Group

White	24	(77 percent)
Black	4	(13 percent)
Hispanic	3	(10 percent)

Welfare Status Before JTPA

On welfare 18 (58 percent)
Not on welfare: 13 (42 percent)
 Supported by husband from job
 savings, alimony, etc. 11
 Exclusively: 7
 Partially: 4
 Working (all partial sources) 6
 Unemployment benefits (partial source) 1
 Parents (partial source) 1

Marital Status

Single 23 (74 percent)
 Divorced: 4
 Separated: 4
 Widowed: 3
 Just said single: 12
Married 7 (23 percent)
 Husband unemployed: 5
 Husband disabled: 2
Living with boyfriend 1 (3 percent)

Supporting Dependents

Yes	27	(87 percent)
No	4	(13 percent)

Training/Occupational Status

Still enrolled in JTPA	15	(48 percent)
Working	9	(29 percent)
Job hunting	1	(3 percent)
Unemployed	3	(10 percent)
In school not through JTPA	3	(10 percent)

Occupational Area in JTPA

Clerical	21	(68 percent)
None (pre-employment only)	4	(13 percent)
Machine trades	3	(10 percent)
Benchwork (assembly)	1	(3 percent)
Sales	1	(3 percent)
Professional and technical	1	(3 percent)

National Survey of Women's Centers

Major Findings

Characteristics of centers with JTPA contracts, as opposed to those without:
> Independent organization
> Established longer
> Larger operation: bigger budget, more staff, more locations,
> serves more women
> More income sources
> More networking activity in community
> Serves more women who are Black
> Poor
> Single parents
> Unemployed
> Older

Top three services offered, in order of frequency:
> Information and referral
> Personal counseling
> Employment services

Major issues addressed in support groups and counseling, in order of frequency:
> Violence -- battering, rape, abuse
> Employment
> Couple problems
> Parenting

Centers with JTPA contracts are more likely to --
> Provide academic or occupational services
> Operate organized social services such as a battered
> women's shelter, displaced homemaker program, crisis hotline

Centers with JTPA contracts are more likely to --
> Be on a PIC mailing list
> Attend PIC meetings

The majority of women's centers' JTPA contracts -- 54 percent -- are for pre-employment programs; 38 percent of the contracts are for skill training. Most contracts have Title IIA funding.

Short contracts: 8.5 weeks average.

Low wages: $4.41 an hour average according to performance standards.

Most centers with JTPA contracts expressed negative opinions about JTPA.

Survey Results

The Sample

Number of questionnaires mailed out	150
Number of questionnaires returned	88
Response rate	59%
Number of states represented in sample	41

Centers with current or past JTPA contracts	17, or 19 percent
Centers with no JTPA contracts	71, or 81 percent

About the Women's Centers

Institutional Affiliation

	Total	With JTPA	No JTPA
Two-year college	16%	12%	17%
Four-year college	4	6	4
University	26	0	32
Voc/tech school	2	0	3
Independent	37	76	28
Non-educational affil.	16	6	15

Budgets

	Total	With JTPA	No JTPA
Latest annual budget	$248,485	$ 539,294	$174,697
Highest budget		1,300,000	978,000
Lowest budget		84,000	1,000

Average value of a center's JTPA contract(s) for the current year is $164,722, or approximately half the annual budget difference between centers with JTPA contracts and those with none.

Number of locations per center

	Total	With JTPA	No JTPA
Average no. of locations per center	1.8	2.1	1.7
Fraction offering full services	1/3	1/2	1/4
Fraction offering partial services	2/3	1/2	3/4

Staff members

	Total	With JTPA	No JTPA
Avg. paid, full time	7	18	4
Avg. paid, part time	7	10	6
Avg. volunteer, full time	0.5	0.6	0.4
Avg. volunteer, part time	27	52	22
Average total staff	41	81	33

Income sources

Below, "any" means any income, large or small, from a funding source; "major" means that the source provides a major proportion of the center's income.

	Total		With JTPA		No JTPA	
	Any	Major	Any	Major	Any	Major
From affiliated inst.	52%	45%	18%	12%	61%	54%
From membership fees	39	2	71	0	31	3
From user fees	49	10	65	12	35	10
From fundraising	45	16	76	23	56	14
From product sales *	19	5	18	6	15	4
From restricted grants	60	43	88	82	54	34
From corporate grants	34	5	53	6	30	4
From foundation grants	25	6	47	12	20	4
From federated grants	23	27	76	47	28	23
From indiv. contribs.	55	7	65	6	52	7
From local govt.	9	7	0	0	11	8
Average no. of income sources	4.4		5.8		4.0	

* Products sold by centers included Guatemalan weavings, UNICEF cards, marriage licenses, books, birth control devices, feminist posters, T-shirts, calendars, bumper stickers, banners, coloring books, consulting services, and space rental.

Community networking contacts

	Total	With JTPA	No JTPA
Extensive	60%	71%	58%
Moderate	34	29	35
Little	5	0	6
None	1	0	1

Role of membership in center's activities

	Total	With JTPA	No JTPA
Closed to all but members	0	0	0
Open to everyone	85	71	89
Members have priority	15	29	11

Years in operation

	Total	With JTPA	No JTPA
On average	13.8 yrs.	16.6 yrs.	13.2 yrs.
Without YWCA's *	10.5	13.0	9.9

* A few centers with YWCA affiliations answered this question with very high numbers (i.e., 97 years). The age of the centers has therefore been calculated separately without this distortion.

Number of women served in the last year

	Total	With JTPA	No JTPA
Average no. of women	4,363	6,629	3,797

Women as percentage of clientele

	Total	With JTPA	No JTPA
Average percentage female	94%	92%	94%

Race of clientele

	Total	With JTPA	No JTPA
White	71%	68%	72%
Black	13	20	12
Hispanic	10	9	6
Asian	2	1	2
Native American	2	1	2
Other	1	1	1

Campus or community women as clients

	Total	With JTPA	No JTPA
Campus women	34%	12%	39%
Community women	66	88	61

Age of women served by centers

	Total	With JTPA	No JTPA
Children	5%	4%	5%
Teenagers	5	5	5
20 - 29	25	19	27
30 - 39	27	28	27
40 - 49	16	30	13
50 - 59	10	9	11
60 and older	4	4	4

Income status of clients

	Total	With JTPA	No JTPA
Poor *	27%	45%	23%
Low income *	30	29	31
Middle income *	35	20	39
Upper income *	7	6	7

* Respondents were asked to use local standards.

Family status of clients

	Total	With JTPA	No JTPA
In couple, with children	24%	17%	26%
In couple, no children	9	6	10
Single, with children	44	56	41
Single, no children	22	20	23

Occupational status according to major activity

	Total	With JTPA	No JTPA
Working	28%	11%	31%
Unemployed	29	62	21
In school	28	11	32
At home	14	11	14

Major reasons women come to center (fill-in answer)

	Total	With JTPA	No JTPA
Information & referral	40%	29%	42%
Personal counseling	39	18	44
Employment services	32	82	20
Career counseling	30	29	30
Domestic violence	23	41	18
Academic counseling	23	35	20
Sexual assault	14	24	11
Personal skill devt.	14	0	17
Child care	7	0	8
Crisis intervention	7	6	7
Networking & contacts	7	6	7
Health	6	0	7
Financial aid	5	0	6

144

Major reasons women come to center, continued

	Total	With JTPA	No JTPA
Legal help	5	0	5
Displaced homemaker services	5	24	0
Teen services	2	6	1

Issues addressed in support groups

Below, "any" means that the issue was addressed at all in support groups; "major" means that the center considered the issue an important focus.

	Total		With JTPA		No JTPA	
	Any	Major	Any	Major	Any	Major
Couple issues	66%	42%	59%	6%	68%	52%
Parenting issues	54	29	53	24	70	30
Employment issues	66	43	82	76	62	35
Substance abuse issues	43	16	35	12	45	17
Financial issues	48	19	47	12	48	21
Lesbian issues	35	8	29	0	36	11
Violence issues	60	45	53	47	62	44
Health issues	52	20	35	12	56	23

Issues addressed in individual counseling

	Total		With JTPA		No JTPA	
	Any	Major	Any	Major	Any	Major
Couple issues	66%	37%	71%	29%	65%	46%
Parenting issues	67	40	71	29	66	43
Employment issues	73	41	94	88	68	52
Substance abuse issues	48	16	59	12	45	20
Financial issues	50	17	59	29	48	22
Lesbian issues	41	12	41	6	42	15
Violence issues	66	48	65	47	66	48
Health issues	44	13	29	0	48	17

Percentage of centers dealing with these issues in either way, support groups or individual counseling:

Employment issues	82%
Parenting issues	81
Couple issues	77
Violence issues	73
Financial issues	62
Substance abuse issues	58
Health issues	58
Lesbian issues	50

Information services provided to clients

	Total		With JTPA		No JTPA	
	Any	Major	Any	Major	Any	Major
Phone or walk-in referrals	100%	92%	100%	82%	100%	94%
Library	79	37	59	18	84	41
Presentations	91	63	76	41	94	69
Own print or film materials	67	28	71	12	66	31

Organized social services provided to clients

	Total		With JTPA		No JTPA	
	Any	Major	Any	Major	Any	Major
Child care facility	11%	7%	12%	6%	11%	7%
Battered women's shelter	19	18	41	41	14	13
Rape or other hotline	18	18	47	47	11	11
Health or medical ctr.	5	2	6	0	6	1
Teen pregnancy prev. prog.	9	1	24	0	6	1
Displaced homemaker prog.	33	25	65	53	25	18

Academic or occupational services provided to clients

	Total		With JTPA		No JTPA	
	Any	Major	Any	Major	Any	Major
Life planning	45%	34%	69%	56%	41%	30%
Career exploration	61	50	100	94	53	41
Remedial education	25	11	56	31	18	7

Academic or occupational services provided to clients, continued

	Total		With JTPA		No JTPA	
	Any	Major	Any	Major	Any	Major
GED (H.S. diploma)	15	6	44	19	8	3
Pre-vocational training	17	15	50	44	10	8
Job training at center	17	15	56	56	8	6
" " not at center	17	14	38	38	13	8
Placement assistance	35	22	94	75	23	10
Job readiness skills	55	45	100	94	45	35
Post-employment program	19	13	75	44	10	6

About the Centers' JTPA Experience

Knowledge of JTPA

	With JTPA	No JTPA
o Are you eligible?		
Yes	94%	28%
No (but ALL centers are eligible)	0	21
Not sure	6	51
o How knowledgeable are you?		
Completely	65%	3% *
Partly	24	28
A little	11	43
Not at all	0	26

 * These two centers said (incorrectly) they were not eligible
 for JTPA.

	With JTPA	No JTPA
o Are you on the PIC mailing list?		
Yes	88%	24%
No	12	76

	With JTPA	No JTPA
o Do you attend PIC meetings?		
All/most of the time	35%	5%
Sometimes	12	0
Rarely	24	11
Never	29	84

The next two questions were answered by the 17 women's centers that have JTPA contracts or have had them in the past.

Contract focus

o Pre-employment vs. skill training contracts

The 17 women's centers had a total of 62 past or current contracts (average, 3.4 contracts per center). Complete information was provided on 48 of these contracts.

54% of the contracts were for pre-employment services.
38% of the contracts were for skill training.
6% of the contracts were to provide services throughout the SDA area.
2% of the contracts were to provide subsidized employment at the center to individual women.

o Traditionally female vs. nontraditional occupations

Of the 18 contracts that involve skill training:

39% were for traditionally female occupations
28% were for nontraditional occupations
22% were for traditional and nontraditional occupations
11% -- not enough information provided to know.

Contracts since 1984

Year	No. of Contracts	Amount	No. Women	Pct. Placed	Wage at Placement
o Averages of completed contracts:					
1984	12	$ 67,568	70	61%	$5.06
1985	14	95,233	57	58%	$5.07
1986	13	117,883	102	78%	$4.97
1987	5	241,996	171	not avail.	not avail.

o Averages of current contracts:

Year	No. of Contracts	Amount	No. Women	Pct. Placed	Wage at Placement
1987	18	98,181	78	66% *	$4.41 *

* In performance standards

The next seven questions were asked about the 18 current contracts.

Source of contract funds from JTPA

Title IIA for adults and youth	59%
Title IIB for summer youth programs	12%
8 percent setaside for educational programs	17%
3 percent setaside for older workers	12%
Title III for dislocated workers	Ø
Incentive funds for hard-to-serve individuals	Ø
Governor's discretionary funds	Ø

Women served in the contracts

Average number of women served per contract 75 women

Women in general		4 contracts
Special population:	older women	2
" "	on AFDC	2
" "	single heads of families	1
" "	high-risk youth	1
" "	14-16 year old girls	1
" "	teen parents	1
" "	summer youth	1
" "	hard-to-place women	1
" "	displaced homemakers	1
No response		3

Performance standards

Eight current contracts were performance-based. Averages:

Average adult entered employment rate	66%
Average adult wage at placement	$4.41
Average adult cost per placement	$2,743

149

Length of Training

The average contract was for 8.5 weeks.

Contract activities

Remedial education	31% of the contracts
English as a second language	6%
GED	12%
Career exploration	75%
Job readiness skills	81%
Job counseling	69%
Outreach and recruitment	69%
Intake activities	44%
Supportive services	50%
Job development	44%
Follow-up	44%

Type of training

Classroom training	81%	Some offered more
On the job training (OJT)	31%	than one type.
Work experience	6%	

Funds allowed for supportive services

Average per contract	7.5% of contract value (legal maximum is 15%)

Followup

Most common is 30, 60, and 90 days after completion, but 31% of contracts had no followup requirement.

Reasons for lack of JTPA contract at any time since 1984

 57 centers answered this question:

Lack of knowledge	44%
Doubts about eligibility	18
Job training not center's mission	12
Other local organizations do JTPA	11
Center is too small	11
Center was not encouraged/contacted	7
Applied but didn't win	7
Too much paperwork	4
Performance standards a barrier	4

Opinion of JTPA as a vehicle of job training for women

 71 centers answered this question.

	Total	With JTPA	No JTPA
Positive	8%	0%	11%
Negative	46	75	40
Mixed	18	25	16
Don't know	27	0	33

o Problems with JTPA mentioned most frequently:

 Jobs pay women too little to live on, especially with children; AFDC with its benefits leaves them better off than JTPA jobs

 Intake too rigid; too many needy people are screened out

 Unrealistically high performance standards force programs to "cream" applicants

 System is too inflexible: women need individualized programming

 Supportive services too limited

 Inadequate or no child care

 Inadequate or no transportation assistance

 Combined effect of reading/math requirements that are too high and limit on remedial education that can be offered

 Job training choices are too limited

o Other JTPA problems mentioned less frequently:

 Lack of training-to-work transition services

 System is occupationally sex segregated

 Women are treated in a sexist manner

 OJT employers participate only for the subsidy, do not provide
 needed help to JTPA workers

 The bureaucracy is too political and not sensitive to women's
 needs

 RFP process is too complex

 Reimbursement problems

 Can't find out about the program

o Excerpts from survey comments:

 "Most low-income women have minimal skills and no funds to pay
 child care. Due to the pressure on JTPA agencies to amass the
 numbers as cheaply as possible, usually those with the most
 experience who don't require supportive services are placed in OJT
 positions, where employers who are not properly sensitized to the
 actual purpose of OJT receive subsidies and tax credits for hiring
 skilled workers at minimal wages with no benefits."

 "Due to performance standards, we are forced to screen out those
 women who are most in need, and supportive services money is
 meager."

 "The two most immediate barriers are child care and
 transportation. Child care money is available to women on AFDC,
 but the amounts allowed are often inadequate which in turn adds to
 the already difficult task of finding a child care provider. As
 for transportation, even those who have their own car often do not
 have enough money for gas and repairs. Use of public
 transportation is hampered by routes and schedules."

 "Most low-income women are single parents, and JTPA here does not
 provide child care for the training period. Also, the job market
 for which JTPA prepares them does not provide a wage which allows
 for the purchase of health insurance or child care. With this
 realization, many low-income women feel they are better off
 remaining on AFDC."

152

"Those most in need, our participant of choice, need a more individual approach, education, and supportive services -- that JTPA can't or won't pay for. JTPA does not systematically plan training programs that recognize women's status as caregivers to the young and elders. It takes longer than one year to take many low-income participants to the level where they can make a living wage."

"JTPA training is not long enough. The training places women in minimum or low-paying jobs, forcing them and their families to live below the poverty level. As a women's center, I feel we should encourage these women to train for higher paying positions."

"JTPA would be adequate if the results proved that women could obtain jobs that were not poverty jobs at $3.45 an hour."

"JTPA reports that job placement rates are high. However, the training is usually in occupations that pay very low wages -- seldom a 'step up' from AFDC income."

"Performance-based contracting forces agencies into 'creaming.' Without skill training and GED, women go into work at minimum wage or slightly above. They soon learn they can't subsist on this, so they have to go back on the system, feeling even more like a failure."

"JTPA pushes vulnerable women with few choices into short-term, very pressured class training situations, and then shoves them out into the workforce to very low-income jobs. I don't think it produces a very good result in the long run."

"JTPA seems to concentrate training programs in clerical and other low-paying fields."

"Most women are guided toward training programs in areas traditionally the domain of females: secretarial, nursing, etc."

"Our JTPA program tracks low-income women into low-income jobs such as secretarial and bookkeeping. The choices open to them are very limited."

"I see five to ten women a month who are eager to retrain, are solely responsible for themselves and probably some family, and who do not meet JTPA standards. I assume this is usually because the women have earned some income in the past 13 weeks rather than starve. The '10 percent window' that is supposed to serve displaced homemakers has never appeared here."

"I feel JTPA is interested in participants who are 'natural achievers,' those clients who merely need a push in the right direction. It is not receptive to clients who are more difficult to place."

"From what I know of JTPA, it seems to be a program designed to provide industry with a labor pool, not to improve the economic status of poor working people."

"I have been active in this community for 18 years and well remember CETA, but I have learned more about JTPA from this questionnaire than any other source, including my local PIC."

- - APPENDIX B - -

INFORMATION SOURCES

Interviews Conducted

The organizations and people listed below were interviewed for this book between November 1987 and January 1988.

Sacramento, California

Sacramento Women's Center	LaVera Gaston
	Marie Tabarez
JTPA	Pat Coleman
Women in JTPA	Michelle Respers
	Reda McElhiney
	Paula Gutierrez
	Jean Fennell
	Nancy Guarnera

Stockton, California

San Joaquin Women's Center	Tillie Serrano
	Judith Jones
	Beverly Ford
JTPA	Marcello Lopez
	Elsie Cuadra
	Jan Starnes

Women in JTPA

Antonia Rosas
Marion Robinson
Anna Bryant
Brenda Ryall
Rhonda Chapman
Carrie Westernoff

San Joaquin Delta College

Marie Pepicello

California Human Development Corp.

Adolfo Torrescano
Marguerita Villanzuela

Council for the Spanish Speaking

Judy Ortega

Colorado Springs, Colorado

The Women's Resource Agency

Delores Quinlisk
Ethel Tamblin
Fran Rider
Ed Raye

JTPA

Peggy Sebera
Gaylord Killinger
Mike St. Clair

Women in JTPA

Wanda Dougherty
Debra Hardy

Accelerated Manpower Opportunities

Jose Cedillos

Golden, Colorado

Women's Center at Red Rocks
Community College

Karen Chronowski

Jefferson County Employment and
Training Service

Susan Rumley

Wider Opportunities of Work

Anonymous

Washington, D.C.

Wider Opportunities for Women

Barbara Makris
Barbara Nalls

Tampa, Florida

The Centre for Women Trudy McFadden
 Maeve Reddin

FACE Learning Center Pat O'Connor

Fort Wayne, Indiana

Fort Wayne Women's Bureau Harriet Miller
 Kris Hayworth-Connelly
 Monica Pugh
 Pam Roberson
 Suzy Gemmer
 Jeanne Harber-Porter
 Patty O'Brien
 Sue Stubbs
 Ginny Purcell

JTPA Betty Lou Nault
 Kathy Swaim
 Margot Altevogt

Woman in JTPA Diane Fahlsing

Louisville, Kentucky

Creative Employment Project, YWCA Betsy Jacobus
 Pat Brodie
 Louann Schroeder
 Pam McMichael
 Gloria Baluffi
 Esther Morton
 Mary Ann Hyland-Murr
 Renee Campbell
 Maria Beckman

JTPA Carroll Synder
 Jack Meesberg
 Judy Sullivan

Women in JTPA Jean Mattingly
 Mabel Hardesty
 Dorothy Dant
 Mary Tucker

Muskegon, Michigan

Every Woman's Place	Judy Hayner
	Mary Oudsma
JTPA	Paul Roy
	Wendy Ohst
Women in JTPA	Connie Coon
	Mary Mitchell
	Debbie Dodge
West Port Vocational Assessment Center	Rich Tejchma
Skill Training Center	Herm Stephens
	Gene Ross
	Cindy Freeney
Muskegon Business College	Bob Hogan
Chamber of Commerce OJT Program	Char Anderson

Buffalo, New York

Everywoman Opportunity Center	Myrna Young

East Stroudsburg, Pennsylvania

The Women's Center at East Stroudsburg University	Pat Grady
	Mary Kiernan

Houston, Texas

Houston Area Women's Center	Judith Stevenson
Houston Area Battered Women's Shelter Network	Rhonda Gerson
	Gail Hunter
	T.W. Curry
	Rebecca Jasso
	Linda Madeksho
	Nancy Harrington
	Barbara Quiroz
	Maria Emerson

JTPA Nelson Davis
 Terry Hudson

Everett, Washington

 Women's Center at Everett
 Community College Joan Tucker
 Laura Hedges

 JTPA Rick Lengyel
 Kathy DiJulio

 Women in JTPA Chris Krueger
 Barbara Moore
 Sharon Mottley
 Nancy Knol

 Operation Improvement Carol Frye
 Merle Langford

 World for Women Anne Gordon

Milwaukee, Wisconsin

 Milwaukee Women's Center Kathy Hinish Peetz

Waukesha, Wisconsin

 The Women's Center Julie DeSmith
 Gail Herndon

 JTPA Sandy Lindner

 Women in JTPA Janice Wilson
 Kay Welch
 Socorro Robelas
 Regina Scaria
 Barbara Turley
 Joanne Burdick
 Debra Hutchins

 Kaiser Employment Agency Randy Meyer

ORGANIZATIONS SURVEYED

The following women's centers completed our survey on women's centers and JTPA during the summer of 1987.

| WOMEN'S CENTER | LOCATION |

Alabama

Women's Center, Enterprise State Junior College — Enterprise

Alaska

Fairbanks Women's Center, University of Alaska — Fairbanks

Arizona

Adult Re-Entry Center, Glendale College — Glendale
Adult Re-Entry Center, Mesa Community College — Mesa
Re-Entry Center, Phoenix College — Phoenix

California

Holy Cross Center for Women — Fresno
CSU Fullerton Women's Center — Fullerton
Continuing Education Center for Women,
 Long Beach City College — Long Beach
Feminist Women's Health Center — Sacramento
Sacramento Women's Center — Sacramento
Womancare Clinic — San Diego
Women's Center of San Joaquin County — Stockton

Colorado

Center for Educational and Career
 Transitions, University of Colorado — Boulder
Women's Resource Agency — Col. Springs
Women's Center, Red Rocks Community College — Golden

Connecticut

Women's Center, University of Connecticut Storrs

Delaware

YWCA of New Castle County Wilmington

District of Columbia

Wider Opportunities for Women Washington

Florida

Continuing Education for Women,
 Brevard Community College Cocoa
Center for the Continuing Education of
 Women, Palm Beach Junior College Lake Worth
South Brevard Women's Center Melbourne
Center for Continuing Education for Women,
 Valencia Community College Orlando
The Centre for Women Tampa

Hawaii

YWCA Women's Resource Center Lihu'e

Illinois

Women's Resources and Services,
 University of Illinois Champaign

Indiana

YWCA Women's Resource Center Elkhart
Fort Wayne Women's Bureau Fort Wayne
YWCA of St. Joseph County South Bend

Iowa

Ames-ISU YWCA, Iowa State University	Ames
Women's Resource/Action Center, University of Iowa	Iowa City

Kansas

Women's Resource Center, Kansas State University	Manhattan
Everywoman's Resource Center	Topeka

Kentucky

Creative Employment Project, YWCA	Louisville

Maine

Transitions Displaced Homemaker Project, University of Maine	Augusta

Maryland

YWCA Woman's Center	Annapolis
Maryland New Directions	Baltimore
New Phase Career Center	Rockville
A Woman's Place	Rockville

Massachusetts

Everywoman's Center, University of Massachusetts	Amherst
Women's Services Center	Pittsfield

Michigan

Center for Women's Services, Western Michigan University	Kalamazoo
Every Woman's Place	Muskegon

Missouri

Women's Center, University of Missouri	Kansas City

Montana

Women's Resource Center, Montana State University Bozeman
Women's Place Missoula

Nebraska

Women's Resource Center, University of Nebraska Lincoln

New Jersey

Women's Center, Jersey City State College Jersey City

New Mexico

Women's Center, New Mexico State University Las Cruces

New York

Everywoman Opportunity Center Buffalo
Womanspace Great Neck
Center for Women's Development,
 Medgar Evers College New York City
Brooklyn College Women's Center New York City
National Congress of Neighborhood Women New York City

North Carolina

Orange County Women's Center Chapel Hill
The Women's Center Raleigh

North Dakota

Women's Network of the Red River Valley Fargo

Ohio

Women's Programs, Cuyahoga Community College Cleveland

Oklahoma

Displaced Homemaker/Single Parent Program,
 Pioneer Area Vo-Tech School Ponca City
Family Resource Center, Oklahoma State University Stillwater

Oregon

Women's Resource & Referral Center,
 University of Oregon Eugene

Pennsylvania

Women's Center, Cedar Crest College Allentown
The Women's Center, East Stroudsburg University E. Stroudsburg
Women's Center of Montgomery County Jenkintown
Tioga County Women's Coalition Mansfield
Oakland Women's Center Pittsburgh

Rhode Island

Women's Center, University of Rhode Island Kingston

South Dakota

Resource Center for Women Aberdeen

Tennessee

Knoxville Women's Center Knoxville
Women's Center, University of Tennessee Knoxville
Women's Counseling Center of Tennessee Memphis

Texas

Austin Women's Center Austin
Adult Center, Brookhaven College Dallas
The Women's Center of Dallas Dallas
Women's Center, El Paso Community College El Paso
Family Crisis Center Harlingen
Houston Area Women's Center Houston

Texas, continued

 Permian Basin Center for Battered Women
 and Their Children Midland
 Bexar County Women's Center San Antonio
 Hays County Women's Center San Marcos

Utah

 Women's Resource Center, University of Utah Salt Lake City
 YWCA of Salt Lake City Salt Lake City
 Women's Center for Life Long Learning,
 Logan State University Logan

Virginia

 Women's Center, Old Dominion University Norfolk
 Women's Resource Center, University of Richmond Richmond

Washington

 Women's Center, Green River Community College Auburn
 Women's Programs, Everett Community College Everett

West Virginia

 Women's Information Center Morgantown

Wisconsin

 Milwaukee Women's Center Milwaukee
 The Women's Center Waukesha

Wyoming

 Women's Center, University of Wyoming Laramie

- - APPENDIX C - -

BIBLIOGRAPHY

National Studies and Publications on JTPA and Women

Wider Opportunities for Women

"'All in a Day's Work' Convention: On-Site Survey Final Report." Wider Opportunities for Women, Inc., 1325 G Street, NW, Lower Level, Washington DC 20005. November 1987, approximately 25 pages.

Although not exclusively about JTPA programs, this is a report on a survey conducted with 400 representatives of women's employment and training programs and displaced homemaker programs attending a national conference on women and work in November 1987. Responses addressed funding sources, client services and barriers, and job outcomes for clients. The survey confirmed our results about child care, low-wage jobs, and sex-traditional placements, and calls attention to women's need for literacy and academic remediation services.

Grinker, Walker and Associates

"The Job Training Partnership Act Service to Women." Katherine Solow with Gary Walker. Grinker, Walker and Associates, 130 W. 42nd Street, New York, NY 10036. 1986, 63 pp.

Report on survey and site visits with 25 SDAs in 15 states plus phone interviews with 32 additional SDAs in 20 states about Title IIA. Information on local programming: enrollment and participation, recruitment and assignment, training, placement and wages, specific issues for women (nontraditional training, support services, the 10% window, and special training programs for women) and oversight and policy development. Major conclusions: JTPA's low funding level, performance standards, and lack of targeting requirements for all but AFDC recipients result in poor performance for women in terms of nontraditional job training, support services, and wage at placement.

167

Displaced Homemakers Network

"Is the Job Training Partnership Act Training Displaced Homemakers? A Technical Report on Services to Displaced Homemakers under JTPA." No author listed. Displaced Homemakers Network, 1010 Vermont Avenue NW, Suite 817, Washington DC 20005. October 1985, 26 pp., $10.00

Report on survey of 425 displaced homemakers programs (184 responses) in winter 1985 to determine the extent and nature of services to displaced homemakers under JTPA and problems that work against displaced homemakers benefitting from JTPA. Among findings: more than half the contracts had to meet higher placement standards than the Department of Labor had established, some said they had to meet lower wage standards, and most had MUCH lower cost/placement standards. Also included is a discussion of reasons for not having JTPA contracts.

League of Women Voters

"Women in Job Training." League of Women Voters Education Fund, 1730 M Street NW, Washington DC 20036. January 1986, 10 pp.

Results of JTPA monitoring by League chapters in 12 areas (= cities or states). Major conclusions: few women are receiving training for nontraditional occupations, women are less than a quarter of the PIC membership, SDAs are spending less than their full supportive services funds, and low wage at placement results in less total income to women than they had had as AFDC recipients.

MDC, Inc.

"The Job Training Partnership Act and Women: A Survey of Early Practices." No author listed. MDC Inc., 1717 Legion Road, PO Box 2226, Chapel Hill NC 27514. February 1985, 30 pp. plus appendices.

Study of 38 SDAs, especially southern, rural, and known to be sensitive to women's needs, on the first year of JTPA. Concluded that poor performance in terms of women comes from emphasis on performance standards, elimination of stipends, low funding level, and de-emphasis of work experience.

The Urban Institute

"Programs for Displaced Homemakers in the 1980's." Carolyn T. O'Brien and Demetra S. Nightingale. The Urban Institute, 2100 M Street NW, Washington DC 20037. September 1985, 84 pp. plus appendix.

Report on interviews of 16 state administrators for displaced homemaker programs and 20 local program directors. Relatively little JTPA funding was found for these programs.

Wider Opportunities for Women

"Monitoring JTPA: How Does it Work for Women?" Summary report. Wider Opportunities for Women, 1325 G Street NW (Lower Level), Washington DC 20005. June 21, 1985, 10 pp.

Summary of presentations by nine organizations that have been monitoring JTPA to share findings on women. They were: National Alliance of Business, Women's Bureau/USDOL, Rural Coalition, National Displaced Homemakers Network, National Coalition on Block Grants and Human Needs, National Women's Law Center, U.S. General Accounting Office, MDC Inc., and Wider Opportunities for Women

Women's Bureau, USDOL

"JTPA Data on Women": Memorandum from Jayne Seidman, Chief, Office of Experimental Programs and Technical Assistance, to Lenora Cole Alexander, Director. Women's Bureau, U.S. Department of Labor, 200 Constitution Avenue NW, Washington DC 20210. Undated but probably 1985. 14 pp.

Statistics drawn from Westat Inc. data on women in JTPA in the 9-month transitional period (October 1, 1983 - June 30, 1984) and the first six months of Program Year 1984. Found that more than half the enrollees were women, that women were overenrolled in classroom training, and that women's wages at placement after all types of JTPA training were on average 86% of men's.

Jobs Watch Alert

"Job Training Partnership Act and Women." In **Jobs Watch Alert**, published by the Center for National Policy Review, Catholic University of America School of Law, Washington DC. January 9, 1985, 15 pp.

Articles: "Women's Coalition Faults State JTPA Plans," "JTPA is Missing Displaced Homemakers and Older Women" by Milo Smith, "Women Facing Problems Under JTPA" by Nancy Dalby, "Women's Bureau Effort on JTPA Starts, Slows," and "WOW: A Case Study of the Struggle to Meet Women's Job Needs Under JTPA." The latter article focuses on WOW's experience as a JTPA service provider.

Women and Work

"Federal Job Training Policy and Economically Disadvantaged Women" by Sharon L. Harlan. **Women and Work 1: An Annual Review.** Sage Publications, Beverly Hills, 1985, pp. 282-310.

Analyzes the impact of CETA and JTPA policy and practice on economically disadvantaged women. Excellent review of the research literature (mostly on CETA) with respect to opportunities for enrollment, participation in different types of training, and occupational segregation.

State Studies and Publications on JTPA and Women

Wisconsin

"Services to Women in Wisconsin's Major Employment and Training Programs." Employment and Training Policy Paper No. 4. By Dana Adler and Sheryl Head, Wisconsin Department of Industry, Labor, and Human Relations, Division of Employment and Training Policy, Madison, Wisconsin. June 1986. JTPA section: pp. 24-34.

In analysis of Program Year 1984, concludes that Wisconsin women were underrepresented in JTPA, had lower entered employment rates and lower wages on placement, and were trained in traditionally female occupations.

Indiana

"Indiana Women in JTPA." Indiana Office of Occupational Development, 150 W. Market Street, Indianapolis IN 46204. June 1986, 38 pp.

Report examines women's roles in JTPA as participants, administrators, and service providers from data collected in PY 1984. Very interesting charts (app. A and B) showing M/F occupational placements, wages, and hours worked per week, with expected results: occupational segregation, usually lower wages for women. Most of the state's 17 SDAs have no training contract with women's CBO's (p. 32).

Michigan

"Michigan Survey Report on Supportive Services: JTPA Title IIA." Elizabeth H. Giese, Michigan Department of Labor, Bureau of Employment Training, Lansing MI. June 1985. Vol. 1, Summary: 22 pp. plus

attachments. Vol. 2, Report: 36 pp. plus appendices.

Survey of all 26 Michigan SDAs in early winter 1985 on how they provide supportive services. In Michigan, women were 64% of the economically disadvantaged population but only 46% of JTPA enrollments. Study found mixed but generally poor provision for supportive services. The most frequently cited cause of dropouts from Title IIA training programs was transportation, and 70% of these dropouts were women.

"How to Help Women Succeed in JTPA, 1986" A conference report by Elizabeth H. Giese, Project Director. Michigan Department of Labor, June 1986, 15 pp. plus 3 appendices.

Outcome of conference of agencies providing services under JTPA. Contains recommendations for overcoming resistance to employment of women, how to help women succeed in JTPA, local counseling and support networks, entrepreneurial programs, overcoming stereotyping and promoting nontraditional jobs, and dealing with gaps, links, and overlap in job training services.

Illinois

"Job Training Under the New Federalism: JTPA in the Industrial Heartland" by Gary Orfield and Helene Slessarev. Report to the Subcommittee on Employment Opportunities, Committee on Education and Labor, U.S. House of Representatives. Illinois Unemployment and Job Training Research Project, University of Chicago, 1986. 299 pp., including bibliography.

Thorough analysis of JTPA in Illinois with emphasis on federal and state policy as well as practice at the local level. Material on women: pp. 198-201 and 222-29. Found that men were heavily overrepresented in the more desirable OJT as compared to women, and that while 35.5% of those eligible for transportation assistance received it, only 4.6% of those eligible for child care assistance received it.

General JTPA Publications (Not Specifically About Women)

A Second Chance: Training for Jobs. Sar A. Levitan and Frank Gallo. W.E. Upjohn Institute for Employment Research, 300 South Westnedge Avenue, Kalamazoo, MI 49007. 1988, 220 pp.

Current and extensive national analysis of JTPA that draws on the work of researchers, government agencies, responses to the authors' questionnaires, and interviews with JTPA personnel. With thorough

documentation, it reviews the political/legislative history of JTPA's origin, much of what is known about what happens to trainees, and discusses how the program's structure makes the unsatisfactory results almost inevitable. The authors recommend meeting more of the trainees' needs, especially for remedial education and support services; improved monitoring and data collection throughout the system; and more funding. This book is highly critical of JTPA and extremely valuable for understanding the built-in weaknesses of the system.

National Alliance of Business. "What's Happening with JTPA? A Complete Analysis of NAB's 1984 Survey Data." 1985, 45 pp.

Grinker Associates. "An Independent Sector Assessment of the Job Training Partnership Act. Final Report: Program Year 1985." Author not listed. July 1986, 120 pp.

Westat, Inc.. "The Organization of Title III of the Job Training Partnership Act in Fifty States" by Wayne Turnage, Robert Cook, and Ronna Cook. March 1984, approximately 50 pp.

-- "State Level Implementation of the Job Training Partnership Act" by Robert F. Cook **et al.** March 1984, approximately 100 pages plus appendix.

-- "Early Service Delivery Area Implementation of the Job Training Partnership Act" by Cook, Reesman, Rupp, Turnage, and Associa;tes. June 1984, approximately 100 pages plus appendices.

-- "Implementation of the Job Training Partnership Act: Final Report" by Robert F. Cook **et al.** November 1985. Approximtely 250 pp. plus appendices.

United States General Accounting Office. Statement of Richard L. Fogel, Director, Human Resources Division, before the Subcommittee on Employment Opportunities of the House Committee on Education and Labor on GAO's Work Relating to the Job Training Partnership Act." May 2, 1985.

Legislation, Regulations, Hearings, Summaries

Job Training Partnership Act: Public Law 97-300, October 13, 1982. Superintendent of Documents, U.S. Government Printing Office, Washington

DC 20402.

Implementing Regulations for Programs Under the Job Training Partnership Act. Employment and Training Administration, Department of Labor. Federal Register, March 15, 1983, pp. 11076-89.

JTPA: Management Information System - Glossary of Terms and Definitions. Office of Financial Control and Management Systems, Employment and Training Administration, U.S. Department of Labor, 1983, 9 pp.

Job Training Partnership Act. U.S. Department of Labor Program Highlights, Fact Sheet No. ETA 83-3, 2 pp.

Summary and Analysis of the Job Training Partnership Act of 1982 (With Selected Provisions of Interest to Individuals and Groups Concerned about Employment and Training Opportunities for Women). Women's Bureau, U.S. Department of Labor, November 1982, 15 pp.

Job Training Partnership Act. Summary of selected sections of JTPA that are particularly pertinent to women. Wider Opportunities for Women, Washington DC, May 1984, 8 pp.

- - APPENDIX D - -

WOMEN'S CENTERS IN THE UNITED STATES

Sylvia Kramer

Executive Director, Women's Action Alliance

History of Women's Centers

Beginning in the late sixties and seventies, a new kind of community-based women's organization began to appear in cities and towns across the country. Sometimes part of a university or college but most often an independent storefront, a women's center provided a space and a focus for the re-emergent feminist activism of that time.

Women's centers provided programs and services developed directly out of the issues and concerns that sparked the early days of the women's movement. Through centers, women organized consciousness-raising groups, peer and professional feminist counselling, rape speakouts, and other controversial events. Referrals to women gynecologists and to the few reputable clinics that then provided

abortion services were available through women's centers. The need to address issues that were ignored by traditional women's organizations and to provide services that were lacking in the traditional helping professions impelled feminist activists to establish a new kind of local agency.

Women across the country, though working in relative isolation from and in relative ignorance of one another's efforts, created highly similar institutions. Structurally, centers were governed and managed by small open groups who reached decisions by consensus. Matters ranging from the frequency of publication of the newsletter to public stands on issues were settled at meetings and in discussions, in a process of ongoing evaluation to which every woman could contribute.

Financially, most centers depended entirely on private personal contributions and sliding scale membership dues. Many centers incorporated as non-profits but initially very few sought tax-exempt status, intending to be free to take political action. Fundraising, considered at best a necessary evil, was highly concentrated and very efficient. Many centers operated with barely enough cash to get from month to month, but continued operating in such precarious fiscal states for five, seven, even ten years.

Almost without exception, centers operated with an all-volunteer part-time staff. New staff policies and office procedures had to be

developed which encouraged independence and autonomy for every woman who worked at the center, but maintained accountability as well. With only slogans for guidance - "the personal is political," "process over product," etc. - women created new and workable collective structures through which to carry out the political mission of the empowerment of women, beginning with themselves.

Over the course of the 70's, center-initiated activities began to have visible effects. Violence against women, raised as a political issue, led to changes in law enforcement and an increasing public awareness of the nature and prevalence of sexual assault. The economic value of the homemaker was widely recognized. The varieties of sex discrimination in employment grew to include such new terms and concepts as "sex-typed job titles," "job segregation," and "sexual harrassment in the workplace." New organizations - shelters, crisis centers, employment resource centers - developed as center-sponsored work groups and task forces re-examined old problems and proposed new solutions.

The centers that weathered the seventies grew into community institutions. The clear importance of the services and programs they provided, coupled with an increasingly pragmatic view of the process of social change, raised a new set of goals: the financial stability needed to sustain programming, the professional credibility needed to license services, and the community visibility needed to affect social policy. Centers have changed: they continue to struggle with issues

of policy, but now must grapple with more practical problems as well.

What has not changed, however, is the openness of the structure. This openness continues to provide women's centers with an unfailing ability to develop innovative, responsive, and effective programming. Women across the country continue to come together to discuss issues and problems and to design and support programmatic solutions. New kinds of services for older women who were victims of childhood sexual assault and for other special groups are being developed. New perspectives on such issues as pornography, energy, and health are being articulated. Women's centers continue to serve as the entry point for many women into feminist activity and for many issues into a feminist analysis.

The Women's Action Alliance has had a continuing interest in the work of women's centers. The Alliance was aware both of the important role women's centers filled at the local level and of the problems these institutions encountered: geographic isolation, lack of acceptabillity within a community, chronic underfunding. A women's center, though closely tied to its own constituency, was often unaware of work being done, services being offered, and problems being resolved by other women's centers even within the same state or region. To encourage and support existing and developing womeen's centers, the Alliance published a series of manuals: How to Organize a Multi-Service Women's Center (1974), How to Make the Media Work for You (1974), Getting Your Share (1976), and Women Helping Women (1981).

Women's Centers Today

Against all odds, the women's center movement continues to flourish in towns, cities, colleges and universities throughout the country. At the time of the publication of Women Helping Women in 1981 we identified 600 centers; today an educated guess would be that there are more than 3500 centers. While some of the earlier centers did not survive into the 80's, some did, and new ones have established themselves. Those that learned the practical lessons of financial survival are all the stronger, often serving thousands of women in their regions each year. There are few campuses today that do not have a women's center, often supported by the college or university, and frequently serving the surrounding community as well as the educational institution.

Women's centers are no longer a fringe feminist pursuit. They offer vital social services to women and their families, are recognized by state and local authorities and often supported by them. Centers such as the Houston Women's Center, which maintains a staff of 45 and a budget of nearly one million dollars, or the San Jose Center with a staff of twelve and a budget of almost a million and a half, or the San Antonio, Texas center with a staff of 24 and three satellite centers are unusually large but are indicative of the expanding role women's centers are playing in providing needed services. Typical programs found in centers throughout the country today are shelter programs for battered women, family violence support groups, job training programs, child care

programs, health services, and counseling/support groups.

What distinguishes women's centers from traditional social services providers are openness of structure, responsiveness to women's needs, accessibility, empathy, and in most cases attitudes which empower women. These characteristics, which shaped the initial women's centers' movement, have remained and continue to promote their growth.

Recognizing that women's centers wanted to connect with other centers to learn from each other, but often did not know where to go or have the financial resources to find out, the Alliance's Women's Centers Project was established to create the National Association of Women's Centers. There were regional meetings held in Great Neck, New York and in Washington, D.C. in 1983. Then in 1984 a national exploratory meeting was held in Grailville, Ohio, at which representatives of women's centers from across the country drafted a statement of purpose and by-laws, and elected a pro-tem steering committee. The group also decided to build regional representation through regional conferences. Two were held, in Montgomery County, Pennsylvania, and in San Jose, California.

A second national meeting was held in 1985, this time to plan the Association's first national meeting to be held in San Antonio, Texas. Planning the convention took enormous effort on the part of all involved. Working without funding, many decisions were made via

conference calls and letters. Determination and a larger sense of purpose - the need for women's centers to come together and empower each other - sustained the 13-member steering committee through the year.

Finally in May 1986, more than two hundred and fifty women, representing women's centers in forty-one states, attended the founding convention. They went to workshops on center management issues, programming, and self-development. Plenary sessions resulted in the ratification of the by-laws and goals of the new National Association of Women's Centers. A 15-member coordinating council was elected and represented diverse constituencies: Native American, Asian American, Black, Hispanic, Chicano, and Lesbian women as well as others.

Since then, the Association has grown. Hundreds of centers are members. There is a newsletter and a mailing list of thousands of women's centers. A membership survey is underway. A second national meeting was held in the summer of 1988 in Milwaukee, Wisconsin. News of the Association has begun to spread widely. Women's Centers across the nation are responding out of a recognition that through unity we can strengthen each other, foster the goals of women's centers, and give voice to the needs of women everywhere.